THE PRO KNOW-HOW™ BOOK OF

SUCCESS IN THE ARTS

What it Takes To Make It in Creative Fields

by
A. Michael Shumate

Elfstone Press

Copyright © 2007, Elfstone Press Inc.
and A. Michael Shumate
Cover design and illustration by A. Michael Shumate

All rights reserved. This book, or parts thereof, may not be reproduced in any form without permission from the publisher; exceptions are made for brief excerpts used in published reviews.

Pro Know-How is a trademark of Elfstone Press Inc.

Elfstone Press Inc.

198 Chelsea Road	52 West Patterson Street
Kingston, Ontario	Mascoutah, Illinois
Canada K7M 3Y8	USA 62258

613-767-9147 tel
613-767-9133 fax

LCCN: 2006908989

Library and Archives Canada Cataloguing in Publication
Shumate, A. Michael (Alexis Michael), 1947-
Success in the Arts : What It Takes to Make It in Creative Fields
/ by A. Michael Shumate.
Includes index.
At head of title: The Pro Know-How Book of.
ISBN 978-0-9739333-5-2
1. Arts--Vocational guidance.
2. Creation (Literary, artistic, etc.)
3. Creative ability. I. Title.
NX163.S48 2007
700.23
C2006-906024-X

Careers, Acting, Music, Writing, Film, Dancing, Visual Art, Photography

Pro Know-How™ Books are not written for dummies or for complete idiots. Instead, they are written by experienced professionals for people who have aspirations to acquire skills at a professional level through study and applied effort.

The information in this book is offered on an "as is" basis. It is largely a work of personal opinion, and as such, carries no warranty or guarantee of results specified or implied. Neither the author nor the publisher shall bear any liability to any person or entity with respect to any liability, loss or damage a person may perceive to have been caused by following precepts found herein.

Printed and bound in the United States of America
10 9 8 7 6 5 4 3 2 1

Books from Elfstone Press are available at quantity discounts for bulk sales as premiums, sales promotions, fund-raising or educational use. Special books, booklets or excerpts can also be created to accommodate needs.

Dedicated to the three greatest mentors in my art and in my life: my mother, my father, my wife.

Success in the Arts: What It Takes to Make It in Creative Fields

Contents

	Acknowledgments	7

SECTION 1: PERSONAL EXPERIENCE — 9
1. Who Is the Grand Poobah? — 11
2. Fame at an Early Age — 17
3. Trial By Ordeal — 21
4. The Issue of Talent — 25
5. To Catch A Monkey — 29
 - Eat an Elephant — 31
6. Challenging Decisions — 33

SECTION 2: TALENT — 37
7. **Everybody has some talents** — 39
 - The Magic of Talent — 39
 - Inclination, Aptitude and Skill — 41
 - Talent and Tangent Skills — 42
 - Craft — 42
8. **Discover Your Talents** — 45
 - Definition of talent — 45
 - Intelligence — 45
 - Personal Strengths — 46
 - Dyslexia — 47
 - Nurture or Nature? — 48
9. **Models of Talent** — 49
 - The Soil Model — 49
 - The Seed Model — 50
 - Why Worry About It? — 52
10. **What is Creativity?** — 53
 - What Creativity Isn't — 53
 - What Creativity Is — 55
 - Brainstorming — 56
 - Thinking Outside the Box — 57
 - Using Your Back Burner — 57

SECTION 3: SMARTS 59

11. **Using Your Smarts** 61
- Learning Tricks 63
- The Cycle 64
- Seek a Mentor 65
- Cultivate Challenging Peers 66

12. **Conventions, Rules and Principles** 67
- Conventions 67
- Rules 68
- Principles 69
- Popular Art or Purist? 71

13. **Getting the Breaks** 75
- Luck or Leverage? 75
- Get Out There 75
- Underestimating Your Profession 76
- Work Your Plan 77
- The Art of Sacrifice 77
- Marketing Yourself 79
- Attitude Equals Altitude 80
- Aim for the Top 81
- Networking 81

14. **Don't Pop Your Own Bubble** 83
- Ease Off Before You Pop 83
- Influence, Homage and Plagiarism 84
- Finding Your Own Voice 84
- Never Stop Learning 85
- Take Care of Important Things 87

15. **Prima Donna or Professional** 89
- The Balancing Act 90
- Walk the Fine Line 92

## SECTION 4: HEART					93
16.	Paying Your Dues			95
- Einstein, Mozart and da Vinci		95
- Stretching Yourself				96
- Get Going						97
- Tough times						99
- Face your bullies					100

17.	You Gotta Have Heart		101
- Facing Criticism					101
- Personal Taste					101
- Valid Criticism					103
- Consider Your sources			104
- You Still Have to Be Yourself		106

18.	Getting and Giving			107
- Life As Art						107
- Teaching to Give Back and Learn	109
- No One Wants to be a Wannabe	110
- Don't give up						111

19.	What If I Don't Make It?		113
- Suppose I don't Meet My Goals?	113
- The Journey and the Destination	116

20.	Final Words					119
- About the Author					121
- Index							123

Acknowledgments

As I will mention in the text of the book, there are few things that help you learn faster, better and deeper than the act of teaching. Therefore, my first acknowledgement is to my students over the years. Unlike many college teachers who teach courses that are isolated within a student's education, I am privileged to teach the students in each of the years in our program, from beginning to end. As a result, I develop a great appreciation for not only what my students have become before graduating, but the developing stages along the way. Their questions and needs have formed the bulk of this book.

Several others have been instrumental in encouraging me to make this work a reality. Chief among those have been my Dean, Ian Wilson, and my colleague Andrew McLachlan.

A veritable army of family and friends has edited different iterations of this work along the way. It has been remarkable to me that each one has added unique comments and contributions, not duplicated by anyone else. Beginning with family: my wife Mary and my artist children and children-in-law (in order of age), Nathan Shumate, Bethany and Dwight Wiest, Elizabeth Shumate, Benjamin and Erin Porter, Laura and Stephen Meredith, Adam and Holly Shumate and Spencer Shumate.

Contributions and corrections of those outside of my family are also deeply appreciated for their comments and encouragement: Rick Davies, David Nay and Cathy Edward. I also value the input of my editor, Christine DeCarie.

Success in the Arts: What It Takes to Make It in Creative Fields

Many others of my family and friends near and far have been encouraging and strengthening in this rigorous process.

In those books where I have glanced at the Acknowledgements page, my eyes have quickly glazed over, since I never knew a soul there. Only now, after living the dream and ordeal of bringing a book to life, do I realize how heartfelt all those sentiments must have been for they surely are with me. Not only have these people helped in the formation of the text and content of this book, but as family, friends and colleagues, they have been instrumental in the formation of me. In the end, that will have been their greatest gift. And for that I shall ever be grateful.

Section 1:
Personal Experience

Success in the Arts: What It Takes to Make It in Creative Fields

Personal Experience: Who is the Grand Poobah?

1. Who is the Grand Poobah?

Every year thousands of people decide to try their hand at one of the arts just for personal enrichment: painting, music, drama, writing, dance, filmmaking and so on. Most enjoy the experience and want art to be a part of their life as a hobby or pastime. But others feel a hunger to achieve something professionally in this area and want to dedicate their life, or at least the next part of their life, to trying to make a go of it in that art form. Maybe you are in this second group. If so, this book is for you.

Once you announce your intentions to the world, you'll receive tons of free advice. Much of it will be conflicting. And if it's conflicting, it can't *all* be true, can it? Much of this free advice is "folk wisdom" passed on via the grape vine. It is truly amazing how much sheer stupidity takes on a life of its own, becoming one of those things that "everybody knows." The great writer Bertrand Russell said, "The fact that an opinion has been widely held is no evidence whatever that it is not utterly absurd."

After a while you may get jaded by free advice, thinking that it's worth every cent that you paid for it—nothing at all!

Throughout my life I have tried and tested most of the advice given to aspiring professional artists. Much of the counsel I have heard in my career is both fanciful and bogus. I assume that much of the counsel given to you is similarly worthless.

I have different advice to give. You may think it's stupid, too. But I'm betting that if you give this book some serious consideration, you will see by your own experience in the arts that this advice will serve you well if you follow it. I hope to clear some

of the fog from your path with lessons I have learned and things I deeply believe. I intend to deflate some stuffed shirts and puncture some puffed-up notions of the art world as I go.

The first day of teaching any new students, I tell them to call me Michael, not Professor Shumate or Mr. Shumate. Then I tell them if they forget my name, they can always call me the Grand Poobah. That always gets a laugh from them and it establishes a rapport with my students. They know that even though I have much to teach them, I don't take myself too seriously and will at least try to deal with issues with some humor. They also sense that I anticipate that any respect they gain for me will be earned—I expect none granted by my title or position—and that ego games are not something we'll be playing.

The term Grand Poobah comes from the Gilbert and Sullivan musical *The Mikado*. It is one of many titles that an officious character has granted himself. The term has come to mean "anyone with no real authority but who acts otherwise" (as defined, appropriately enough, in Wikipedia). There you have it. I will speak with great authority where I have none, except that which experience has given me.

And you might ask, "What experience does this guy have?" Fair question. I graduated with a Bachelor of Fine Arts degree in graphic design and I've been a professional designer and illustrator for over thirty-five years. Among my clients are the NFL, Simon & Schuster Publishers, Kelly Services, *British Airways Magazine*, the Screen Actors Guild, *Business Week* and Prudential Financial to name a few. And for the last nineteen years, in addition to freelancing, I've been teaching graphic design and illustration at St. Lawrence College--the last sixteen years as a professor.

Some of you may say, "He doesn't know anything about *my* art." It's true that my personal career has been focused on the graphic arts. But I'm the son of a career musician, and husband to a piano teacher. Plus two of my children are piano teachers and another plays French horn with the Louisville and Phoenix symphonies. Another of my children is a writer, one a photographer,

Personal Experience: Who is the Grand Poobah?

another is a fine woodworker and two others are studying film at university. Yes, I have eight children, all engaged in at least one of the arts. I have plenty of contact with the other arts and their practitioners.

The observations I share in this book apply equally to any and all of the arts. It doesn't matter which art you've chosen because I'm not talking about any individual skills that each of the arts require, but rather how to *succeed* in the arts. These principles apply as much to painting as to music, as much to writing as to film. They also apply as much today as they did fifty years ago.

Because of that, what will likely be of the most value to you in this book will not be some specific technique for your particular art, but an adjustment of your attitudes. Ultimately, I believe this could be the most important thing I can give you. If you read it and understand it, you will be freed from some very prevalent misconceptions about the arts, which have led countless people to make very costly mistakes in their careers and in their lives.

This will be a personal book, from me to you, an aspiring artist. My hope is to save you a few years of trial and error and speed you on to succeed in your chosen art.

In these pages we'll deal with some very important questions:
- What qualities most promote success in the arts?
- How can you know if you have enough talent to make it?
- How do you get through the tough times?
- How do you deal with criticism?
- How do you help yourself "get the breaks" in your field?
- What is real creativity?
- How do you keep the important things in your life and not "sell your soul" to get to the top?
- What if you don't make it?

The Straight and Narrow Path

Many of the things we will discuss here are complex issues. Most will have multiple facets and several possible approaches. Quite often they also have many ways we can mess up, too. At times, it may appear that I'm contradicting myself. While I agree

13

that I'm not immune from that kind of error, I may warn about pitfalls on the left side of the path and other dangers on the right side. That sort of counsel is not contradictory. There will still be a safe path down the middle which may not be easy to walk, but can be navigated if due diligence is given to the principles discussed. It's the proverbial straight and narrow path.

What's My Role?

I've dubbed myself the Grand Poobah. By doing so you should know that I claim two things about myself simultaneously: 1) I have some things to teach you; and 2) I know that I don't know it all and I'm not taking myself too seriously.

You might consider me a coach. One who knows what he does by experience, knows how some things are done and is willing to help you learn how. But remember this, no matter how good the coach is or what medals he may have garnered in the past, the coach can only show and tell (we're all back in kindergarten again); then *you* have to do it.

Think of a diving coach. He shows his pupils how to do the forward one-and-one-half somersault with four twists. He may describe it in detail, move by move. But, in the end, each diver is on the high platform—*alone*.

Naturally, divers don't start their instruction on the high platform. They start at the side of the pool, then move to the low board, then the intermediate board.

And yet, when we see really good divers do their best, it looks so much easier than it is.

So it is with all the arts, too. Repetition makes some things become second nature and appear easier than they are. The master makes it look so natural, almost effortless. Almost like *we* could do it, too.

And that's the bug that's bitten us, all of us who have aspired to any of the arts. We want to be the masters.

That's a good goal. Let's work at it. I won't promise that each of us can do it in the end. But I can outline some of the principles

Personal Experience: Who is the Grand Poobah?

we need to know in order to go as far as our talents, hearts and minds can take us.

The first step is to have an open mind. I don't claim to have all the answers, but I have a great deal for you to think about. John Kenneth Galbraith, the famous economist and philosopher of the twentieth century, said, "Faced with the choice between changing one's mind and proving there is no need to do so, almost everyone gets busy on the proof." It can be hard to change our minds. It's a brave thing to do. The often-quoted Geoffrey F. Albert said, "It often takes more courage to change one's opinion than to stick to it." I'm not asking you to necessarily change your mind, but to give each concept some contemplation. Dr. Wayne Dyer, author of more than two dozen books, said, "If you change the way you look at things, the things you look at change."

So be of good courage and think deeply. In the end, naturally, you'll make up your own mind about what I have to say.

That is as it should be.

But maybe, having pondered the things that I will present to you, and by questioning the mind-set that you have previously held, you may look at the arts with new eyes and perhaps be a little wiser and more directed in your goals.

I hope so. I wish you success.

This Book's Set-up

This book's first section is largely autobiographical. It will lay a conceptual foundation for the principles that will be discussed in greater depth in sections two, three and four.

Success in the Arts: What It Takes to Make It in Creative Fields

Personal Experience: Fame at an Early Age

2. Fame at an Early Age

When I was nine, suffering from frequent bouts of boredom, I saw somewhere instructions for drawing the face of Mickey Mouse. In the days before Pokemon, Spiderman and Star Wars, Mickey Mouse was the coolest character I knew. I followed the drawing instructions: a couple of ovals, a few curved lines, a circle or two and a few connecting arcs and, voila! There was Mickey himself staring back at me.

This was genuine magic to me, but the best part was that *I* was the magician! I was thrilled with what I had done. I drew Mickey's face over and over. Before long I could do it from memory and did so at every opportunity. At school one of my little friends saw me drawing and was spellbound. "Wow! You're an artist!"

I loved it! I believed it, too.

With that kind of encouragement, I sought out and learned how to draw the faces of Donald Duck and Goofy. Now I had a repertoire! Three whole faces. No bodies and just one single expression each, but I now drew these faces over and over.

One day, one of my little admirers called the teacher over, "Look what he can do!" The teacher was very encouraging. "My! What an artist you are!"

I loved it! And I believed it, too.

One day I was bragging to my younger sister Cathy (who was about seven or eight) about what a great artist I was because I could draw these three cartoon faces. My mother overheard me. She had studied art after high school and knew that I needed a reality check. She sat Cathy and me down, handed me a pad and

17

Success in the Arts: What It Takes to Make It in Creative Fields

pencil and told me to draw a portrait of Cathy. My sister could only hold still for about fifteen minutes, which was a good thing because my drawing wasn't going so well. In fact, the drawing looked a lot like George Washington. Just so you know, my sister does not now, nor did she then, look *at all* like George Washington.

Well, I had received quite a jolt.

A few weeks later there was a contest at my school to draw a picture of George Washington in honor of his birthday.

You guessed it. I submitted the picture of my sister Cathy. And I won the contest for the whole school! Now the whole school knew I was an artist.

I loved it! And I believed it, too.

Life went on and I pursued my art with varying success. After a few years, my mother gave me her oil paint set with strict instructions that I was never to waste these paints because they were very expensive. I learned to use them and did a few paintings. One day I decided to paint and began squeezing paints out on my pallet. I had a few colors on the palette when I decided that I really didn't feel like painting after all. But I had all this paint on the palette. And there was no way to put the paint back into the tubes. What was I to do?

I took the small bulletin board with a wooden frame off my wall and smeared the paints onto it. Then I stuck it in the closet.

Some months later my mother saw in the newspaper a notice for a five county art contest. She suggested that I submit my abstract painting.

I asked her, "What abstract painting?"

"The one in your closet. The orange and white one."

"Oh – right. . . *that* abstract painting . . . Sure."

So I submitted the smeared bulletin board to the Five County Art Contest. And I won first place in the abstract division.

My name was in the paper. Now five counties knew that I was an artist.

I loved it! And I believed it, too.

As high school graduation drew near, I did a lot of soul-searching about what career to pursue. I must have had second thoughts

Personal Experience: Fame at an Early Age

about my artistic abilities because I decided to study marine biology at the University of Maryland. I went to school for three semesters and then took a two-year break from school. During that time I did some more self-examination before returning to university. When I did, I decided that what I really wanted to do was art. I loved the magic, and especially I loved being the magician. So I returned to my education, transferring to Brigham Young University as an art major.

Then came a harsh initiation.

Success in the Arts: What It Takes to Make It in Creative Fields

Personal Experience: Trial by Ordeal

3. Trial by Ordeal

I resumed my university education as an art major. I was ready to officially claim the title of artist that people had attributed to me all my life.

(Gulp!) Here goes.

I got into my first figure drawing class. I wasn't sure how I'd do. That didn't last long. I saw the beautiful work that others were producing.

(Gasp!)

My work...was clumsy. Ugly. Amateurish. My drawings still reminded me of the Cathy/George Washington picture. I was not the great artist I had always thought I was. I was mediocre at best. I didn't belong with these other folks. As the weeks went by, my whole self-identity melted into a sticky pool at my feet.

I was ashamed of my drawings. I hung my head at my lack of talent. What was I to do?

After one semester, I couldn't take it any more. I changed majors from art to graphic design. There I could still be visually creative and work with the images of others, not my own, and I wouldn't have to draw.

I actually excelled at graphic design. What a refreshing change! I found I had some natural affinity for type, layout, color, and so on. It also really helped that I landed a part-time student job at a university department that needed lots of brochures and posters designed for special courses and conferences. This accelerated my learning in graphic design. I was getting real pieces printed

Success in the Arts: What It Takes to Make It in Creative Fields

almost every week and, before long, I was well ahead of my fellow graphic design students.

During this same time I got married and we had our first child. We left school for a short time for financial reasons and I worked as a graphic designer at the largest design studio in the state, even though I wasn't finished with my schooling. After nine months, financially stable again, I realized that if I didn't go back to school and finish my bachelor's degree right then, I never would. (Groceries, paychecks and evenings with no homework every night can become *very* addictive, you know.)

So I went back to university and, because of all my professional graphic design experience, I landed a job as part-time faculty, teaching two of the beginning graphic design courses. This was a real blessing because that job not only gave us enough to live on (barely), but it also exempted me from having to pay tuition. What good fortune!

But life wouldn't let me hide from drawing forever. Two of the courses required for my graphic design degree were Illustration 101 and 201. I had put off taking them because I knew I would have to draw in them. Still, I couldn't avoid them anymore, and I had to confront my old nemesis, drawing.

On the first day of illustration class, our teacher—a famous illustrator, graphic designer, and former art director of Capitol Records—gave us our first assignment: to illustrate a scene from a book we had read. I decided to illustrate the entrance to the Mirkwood from *The Hobbit*. I had deliberately picked an inanimate subject. No people or animals, just some spooky trees and mountains. I worked hours and hours on it and was quite pleased with the finished product.

I got to class early and proudly showed my painting to the teacher. "What do you think of that?" I asked excitedly.

He looked it over carefully and then gave a very unimpressed, "Neh."

"Neh?" I said. "What do you mean by 'neh'?! Do you know how long I worked on this?" I felt justified in being upset. My teacher had taught many of my early graphic design courses and

Personal Experience: Trial by Ordeal

was my direct supervisor in my part-time faculty teaching. He knew I was in a difficult position.

He took me into his office, and said, "Listen, Michael. I'm going to exempt you from all of the regular coursework for this class if you'll undertake a special project."

Exemption sounded too good to be true. "OK!" I answered without another thought.

He smiled and grabbed a discarded sheet of illustration board, chopped it up into a dozen chunks about four by five inches and handed them to me. "Here's your project: you're going to do five hundred paintings in acrylic this big."

My jaw fell open and I stammered, "Five–hund–FIVE HUN-DRED?"

"Yep."

"Paintings of what?"

"That's the key: they *can't* be paintings of *anything*. No paintings of people; no paintings of trees, flowers, buildings or deliberate designs of any kind."

"Huh? What do you mean?" My head was spinning. "So you want them to be what—abstract?"

"That's right, abstract. And I want you to vary your color palettes and use a lot of colors sometimes and only a few at others. Learn everything that paint can do."

I wondered, is it too late to back out of this deal? But I had already said I would.

I finished the project. (Actually, I only completed 467 paintings, but he accepted them.) I got an A in my first illustration course. Some of those little paintings still look good today. I have a couple hanging on my office wall right now.

And a miraculous thing had happened. My hands didn't end at my fingertips; they ended with the hairs of the paintbrush. It was a part of me. And the paint was a part of my mind. I knew EVERYTHING that paint could do.

Regrettably, I still couldn't draw worth undercooked beans.

Success in the Arts: What It Takes to Make It in Creative Fields

Personal Experience: The Issue of Talent

4. The Issue of Talent

So I had passed Illustration 101 with an A. Me? Amazing! But I still had to take and pass Illustration 201. The teacher was the same, and there would be no exemption from regular assignments this time.

It was a rigorous course, and I worked very hard. And an interesting thing happened. I decided that I would hide from image-making no longer and instead embraced it whole-heartedly. I not only did my work for illustration class, but began to use illustration wherever possible in my other graphic design projects. Even though I wasn't gifted—I had to use every bit of ingenuity to work around that—still, somehow I recognized that I had returned to my first love: the thrill of the magic of making images.

And I was the magician.

Near the end of that course I heard that my teacher (the same fellow) was telling his other classes about an unnamed student of his that "couldn't draw a stick figure without a ruler," but still managed to create good images because he could "outsmart what he couldn't do with native ability" and because "he was willing to put in the time until it was right." I found out when one of my fellow students had figured out that I was the unnamed student and told me. He said, "Hey, the teacher's talking about you." Initially I thought I was being complimented until he repeated what was being said.

Somewhat offended, I went to my teacher and asked if I was the person he had been talking about. He said I was.

23

Success in the Arts: What It Takes to Make It in Creative Fields

"How could you talk about me to other students?" I demanded.
"Well, I didn't use your name..."
"Yeah, well, someone figured it out!"
He winced.
I asked him what he meant by his statement. And then he gave me one of the best lessons of my life—one that I pass on to you.

"Michael, there are three qualities that promote success in the arts. They are: 1) talent; 2) an ability to accomplish laterally what you can't do directly; and 3) a passion for the work that compels you to work until it is right. If you only have one of those qualities you just won't make it in the arts—even if that quality is talent! If you have all three qualities you can surely be a success in the arts. If you have two out of three, you *might* make it."

Then he looked at me seriously and said, "Michael, you have these last two qualities. You just might make it."

I stood there for a minute with a blank expression. He was telling me I had little or no talent. How could he do that? (Well—I guess I knew all along that it was true, didn't I?) But he also told me that I *could* make it even with the very modest endowment of talent that I had.

I have pondered that counsel many times since that day and believe it to be true. We have all heard about very talented persons in various of the creative arts who have washed out. Just didn't make it in spite of sometimes spectacular talent. Talent is a great thing to have, but it's not enough. You see, even an outrageously talented person has limitations. Nobody can do *everything* well. There's always going to be some area where that person is weak.

That's when "smarts" must take over, the ingenuity to accomplish what cannot be done with your talent. Smarts is not talent, but the ability to get around indirectly what can't be done directly.

The last quality he spoke about is a love of the art and a willingness to keep at something until it works. That's heart. That's loving the work and not giving up until it just clicks.

Personal Experience: The Issue of Talent

Over the years since that pivotal day, I have come to see that the nature of talent is two-fold: one part is natural aptitude and another part is acquired mastery.

Consider two theoretical people with the same amount of inherent talent, but one is a thirty-year veteran of the art and the second person is a newbie. The first person will be able to do much more than the second, but not because of intrinsic ability, just because of the accrued skills that come from years of practicing the art.

Another aspect of intrinsic aptitude may be that a particular aspect of your inborn abilities might not be tapped until a certain kind of work or particular level of work is attempted. We sometimes call these people late bloomers.

I had an aptitude for public speaking that I never knew I had until, at age eighteen, I had to give a twenty-minute talk to about two hundred people. It went so well that some thought I had a lot of previous experience, but it was my first time. Of course, the fact that I spent about ten hours preparing for this twenty-minute talk was also a factor. Who can say how much came from native talent and how much resulted from sheer effort?

I have come to this conclusion regarding talent: how much native ability you have may not matter nearly as much as the effort you put into your art. But you have to also be smart about it and know your limitations, though the boundary of those limitations should be pushed back continually through acquired skills. You also have to love your art enough to keep at it until it works.

I always tell my students that I do better artwork than any one else I have ever met with as little talent. If you want to, you can see if this guy who couldn't "draw a stick man without a ruler" has grown in skills. Decide for yourself. Visit my graphic design/illustration website at: www.VisualEntity.com. All of the work on the website (and the website itself) is my work.

At some level I believe talent is merely an understanding or skill already acquired. In the decades since my reawakened passion for creating images, I have learned many skills and grown

in knowledge. (I think the work shown in my website will attest to that.) I have had to struggle to gain each bit of visual knowledge, but have always found the same thrill from the magic of creating images.

The best part is that *I* am the magician.

And there's nothing better than being the magician.

Personal Experience: To Catch a Monkey

5.
To Catch a Monkey

Somewhere along the way I heard this story.

By the late 1800s it had become fashionable for every big city in the western world to have a zoo. There was a new business born to supply zoos with exotic animals. Among the most popular critters in any zoo were the usual suspects: lions, tigers and bears (oh, my!), elephants, snakes and, of course, monkeys. Many of these creatures were dangerous to bag, but they were still captured regularly by professional hunters. On the other hand, monkeys were not dangerous, but still posed a special problem. They lived in trees, were uncommonly intelligent and communicated with each other. It was nearly impossible to catch them unawares on the ground. If the great white hunters tried to shoot them while they were in the trees, even just to wound them, the fall to the ground was usually fatal. Strangely, most zoos were not interested in dead monkeys.

So the price for monkeys increased because the hunters were unable to meet demand.

Then the native guide to one western hunter told him that he knew how to catch a monkey, alive and unharmed. The hunter eagerly asked to know the secret.

"First you make a box frame and cover it with wire mesh. Have a door on top with a three-inch hole in it."

"And then what?"

"Put some fruit in the box and lock it shut."

"What kind of fruit? Something exotic or foreign?"

"No, just the ordinary fruit that the monkeys eat every day."

29

"I see, old chap. And we wait in the bushes for them to approach the trap and shoot them?"

"No, we leave the box and come back to camp. When we return in a few hours we will have a trapped monkey."

"Eh?"

Well, they tried it.

They made the box frame with wire mesh. Put some ordinary fruit in it. Locked the lid with the hole in it and, skeptically, went back to camp. And what happened was this.

Back at monkey central, the lookout scouts gave the all clear to the rest of the pack. *No hunters present or hiding in the bushes.*

A scout monkey was set down to investigate. *Nothing dangerous. Hey, there's fruit in there! Let me see if I can get it.* It reached into the hole in the top. And grasped the fruit. *Got it!*

The monkey then tried to pull its hand out of the box. But with the fruit in hand, it wouldn't fit through the hole, which was only big enough for its empty hand. *Something's wrong here!* The monkey put its hand back down but it just wouldn't come back out.

Hey guys, I'm stuck!

Some monkeys remained as lookouts for hunters while other monkeys came down to investigate. They looked at the trap from all angles. *Man, you sure are stuck! Don't know how to get you free.* It never occurred to any of them for the trapped monkey to just let go of the fruit. Just not in a monkey's nature to let go once it's grabbed something.

When the great white hunter's group came back, all the other monkeys "went ape" and abandoned their buddy with its hand in the box. *Sorry, man, you're toast. Later.*

Absolutely desperate to escape, the monkey screamed, yelled, cried in fear and tried to get away from the trap, but its hand wouldn't fit through the hole. Still, the monkey wouldn't let go of the fruit.

To a chorus of anxious and agitated monkey chatters from the trees, the native guide gently put a blanket over the frantic, squealing trapped monkey. The trap door was unlocked, the fruit

Personal Experience: To Catch a Monkey

gently taken from the monkey's hand, and the hand was removed from the door hole as the monkey's legs and hands were securely tied. And the monkey spent the rest of its life looking at ogling zoo-goers.

And what, you may ask, is the moral of this story and how does it relate to our discussion here?

Well, it was explained to me that two-dimensional images (the object of my passion) were nothing more than color and form. If you get the color right and capture the forms, the image can't get away. You've bagged another image for your trophy wall. You've caught the monkey.

I know, it's an over-simplification, but it was a breakthrough moment for me.

I still loved being the magician. And if I just used the abilities my teacher said I had, I "just *might* make it."

Eat an Elephant

I was determined to make it. I had also learned that I could gain real skill through work and effort. (Remember the assignment to do the five hundred paintings?) I had also picked up several little drawing tricks that had made my drawing much better.

Anybody can eat an elephant: you just have to do it one bite at a time. With the enthusiasm of youth I decided to learn whatever I didn't know to become a professional illustrator. I determined to eat my elephant, one bite at a time.

This, you will appreciate, is a complete one hundred-eighty degree turn for me, the guy who got into graphic design for the express purpose of avoiding drawing for the rest of his life, especially the drawing or painting of people.

I had a few elective classes yet to take before graduating, so I decided to take a portrait painting class. The first assignment was to do a self portrait. We each had a mirror next to our easels and stood around looking at ourselves and painting. I chose a dabbing, neo-impressionist technique in oil and was very pleased with the end product. I proudly declared to my teacher (different

31

teacher than mentioned before) that I had "found my style." He answered, "Don't be an ass! You are way too young in this journey to settle on a style. You should let every project be a new experiment. Do what the project needs and don't limit yourself by your previous successes."

I was stung. (I should have been used to it by then, but I wasn't.) Still, I took his advice to heart. I determined to honestly let each project determine the style I would use and not make the project conform to what was already familiar to me.

That is good counsel that I give to all beginning artists. It's only natural to have preferences. But at the beginning stage of your education and career, you ought to be seeking to broaden your horizons. As I've already mentioned, some natural abilities will not manifest themselves unless you are trying new things. It would be a shame to fashion a career based on the narrow and immature tastes and abilities we have as adolescents. (Of course, we still expect our beginning high school students to do just that.)

Our goal—and not just at the beginning of our careers—ought to be to grow and expand continually. Once we stop, we stagnate. I am approaching sixty and yet this year I've taken on many new and totally different learning experiences, and I've committed myself to mastering many new skills and art forms. I'm pushing my limits. I recommend it to all. Lifelong learning is a worthy goal.

6. Challenging Decisions

I was finishing up university, for my Bachelor of Fine Art degree. A BFA differs from a Bachelor of Arts degree in that a BA signifies that you know *about* something, whereas a BFA certifies that in addition to knowing *about* the subject, you can *do it,* too. It is what is called a performance degree.

All BFA graduating candidates were required to do a final graduation project before finishing. These were shown every year in a special exhibit before the end of the year. Officially, I was a graphic design major with advertising as my minor. My graduate project could have been related to design or advertising, but I chose to do a series of illustrations from *The Arabian Nights.*

Did you know that the original *Arabian Nights* is actually four hardbound volumes of stories? I didn't. I stumbled across the complete set in the library and was quite intrigued by the variety of stories. Some are the G-rated ones we've all seen in children's books: Sinbad, Alladin, the Genie and the Fisherman, and so on. But other less well-known *Arabian Nights* stories would definitely be PG rated and some even a bit higher.

I undertook some new techniques for this project. I had learned that I could draw better from a photograph than I could from real life, so I used two kinds of photographs. I drew from photos that I took of people (friends who agreed to pose for me) and costume reference pictures to make new original images that did not violate anyone's copyright. The illustrations were better than I had ever done before. I still show some of these on my illustra-

Success in the Arts: What It Takes to Make It in Creative Fields

tion website now more than forty years later. (see http://www.visualentity.com/histpages/hist10.html and http://www.visualentity.com/histpages/hist18.html)

I got an A on my graduate project, graduated and went off to seek my fortune. My wife and I and two-and-a-half kids moved to a rather remote area to be close to family, and I hung out my shingle as a freelance graphic designer and commercial illustrator (I was far enough off the beaten path that there were no full-time jobs available for designer/illustrators). Much to my surprise, the first freelance job I got was as an illustrator. It was detailed nature illustration for a tourism book. I had to paint sixteen species of birds that were native to that area. Once that project was completed, the same client had me do a nature mural eight feet by six feet which featured about thirty specific species of plants and animals. I was becoming a nature illustrator, something I never had imagined. Over the years I have also done and enjoyed other kinds of illustration: advertising, historical, technical, juvenile and editorial.

Because the place we lived in was "in the sticks," there were a few other graphic designers, but I think I was the only commercial illustrator in the whole region. In large metropolitan centers clients tend to look for illustrators who specialize in whatever kind of illustration they are shopping for. In the locality where I lived, I was the "only game in town" and so people came to me with all sorts of illustration—and graphic design-—needs.

I regretted many times, while living in the boonies, the total lack of illustrator peers to commune with. But I have looked back now and realized that my remote locale provided me with more diverse opportunities than I ever would have had in a more populated place.

And I also stayed true to my commitment to approach each project on its own merits. In the fourteen years I lived and worked in that area I mastered acrylic in several different techniques, oil, watercolor, colored pencils, gouache, pastels and latex. In recent years I have also achieved a high proficiency with digital vector illustration and Photoshop. As well, I have deliberately pursued many different styles, both realistic and non-realistic. It was this

Personal Experience: Challenging Decisions

very variety that prepared me to succeed as a professor of graphic design at St. Lawrence College. Several years later we moved to our current home, which is closer to civilization (commercial centers), and I began to teach college. On the side, I embarked on a different kind of freelancing illustration, one that had not been possible in my former locale: conceptual editorial illustration. I worked up a whole new portfolio and began to market my services in Toronto, New York and Washington, DC.

While taking my portfolio around I learned about The Image Bank (TIB), a stock photography agency, which had started to offer stock illustration as well.

Stock photography and illustration have specific restrictions on the usage that a client contracts for, whereas royalty-free photography and illustration have no such controls. Once a person has purchased a royalty-free CD, for instance, there is virtually no limit to the uses that person may make of that image. For this reason, larger commercial clients will not likely wish to use royalty-free material because of its lack of controls, whereas the limits placed on stock usage can guarantee an exclusivity of the image for a period of time within a certain geographic area. I became a contributor to TIB, which was at that time the largest stock photography and illustration agency in the world. Through stock illustration, my illustration work has been used all over the world, and I achieved a fair amount of success with them, renting the use of my illustration to clients like McGraw-Hill Publishers, *British Airways Magazine* and Kelly Services. One of my illustrations was the single most successful image in all the European offices of TIB around 1992.

Although my name is not known to many, I have had a successful career making images, just as I had hoped to do when young.

Just a couple of years ago I stumbled upon the website of my old teacher, the one who had given me that pivotal counsel about talent, smarts and heart. He has retired from teaching and does

35

Success in the Arts: What It Takes to Make It in Creative Fields

beautiful portraits. I contacted him, recounted his advice to me and referred him to my design and illustration website (www.VisualEntity.com). He wrote back and complimented me on what I had done.

I can't begin to tell how often I have pondered the counsel he gave me so many years ago. The three qualities for success in the arts come down to talent, mind and heart. Talent or skill is the ability to accomplish the work required. It doesn't matter which area of creative arts it is, either. Mind is the smarts or ability to sidestep your natural deficiencies to still achieve a desired outcome. Heart is a love of the work and a willingness to keep going until it works.

Those first two qualities, talent and mind can be learned by diligent study and effort. The only one of the three qualities that has to be present in you to begin with is the last one: heart—a love of the work and a willingness to keep at it until it is right. I believe anyone who has a true passion for their art can grow in abilities. It may be slow, but it will happen.

The most beautiful part about a profession in any creative field is that you can always be learning. There is no excuse for ever being bored. You will never know it all, but the learning is precious and the quest for the magic never ends.

And YOU get to be the magician.

Section 2:
Talent

Success in the Arts: What It Takes to Make It in Creative Fields

7. Everybody Has Some Talents.

Certain talents are good enough that others will pay to have you practice them. At least they are good enough that, if you develop those talents, someone might pay you to exercise them.

Not all talents are in the arts, but if you're reading this, you are most likely interested in talents that deal with the creative arts: music, art, film, design, dance, drama, writing and so on. Sorry if I didn't mention your particular art, but it really doesn't matter. As mentioned earlier, these principles apply across the board of creative careers.

That may be a foreign thought to you. Perhaps you have come to think that visual art is fundamentally different than music, and it is. But that's not what we're discussing here. We're not really talking directly about art, music, acting, and so on. We're talking about *succeeding* in those fields and what it takes to do so.

John Locke, the seventeenth century philosopher, warned, "New opinions are always suspected, and usually opposed, without any other reason but because they are not already common."

Therefore, be prepared to be challenged in at least some of your long-held beliefs. I intend to ruffle feathers and mess with your mind. All to better prepare you for success in the arts.

So, down to business.

The Magic of Talent

As mentioned before, if you really want to succeed in a creative field, some of the most important learning you can assimilate is not some secret bit of art instruction or musical insight. In-

stead, one of the most important pieces of your education will be an adjustment in your attitude. Get your head screwed on straight and lots of other problems will either melt away or never materialize. Part of having a world outlook that will help you instead of hinder you is to have realistic expectations. As the great Stephen R. Covey noted, if you are trying to find your way around Chicago, you'll have a rough time not getting lost if you're using a map of Detroit as a guide. You need to have a map that is accurate to the territory you're trying to navigate.

The world of the creative arts abounds in fables and folklore that are genuinely wrong-headed and misleading. If your worldview is off-kilter, you will not progress as well as you would if you could see things more accurately. It's like running an obstacle course with some strange novelty glasses on that distort your eyesight. You will bump into things that you would rather avoid. You will not go where you hoped to go. With an accurate mind-map about the arts you have a fair chance of completing the course. Part of having a helpful, productive world outlook is to have realistic expectations and attitudes.

One such attitude that might need readjustment is how you look upon talent. You will, no doubt have already discovered some talent relating to your chosen art. You may be confident or tentative about your talent. Either way, you're probably hungry to make it grow. This is good. So here is the first big shocker that you need to know: artistic knowledge is like any other kind of knowledge.

What!? Isn't there some sort of magic involved? What about that indefinable *je ne sais quoi* about the arts that intrigues everyone so much?

Yes, it is true that there is magic in the arts, but there's magic in all kinds of knowledge. Some of us don't want to hear that. We may be art snobs, thinking that our artistic talents are greater or more special than someone else's non-artistic talents. Too bad. Snobbery is just another kind of prejudice. The kind that thinks that "we" are somehow better than "them." Prejudice gets the

Talent: Everybody Has Some Talents

world into all sorts of trouble and we'd be better off not contributing to the world's sum total of snobbery. Let's get over it. Artistic knowledge is like any other. By that I mean that *it can be learned*, if you have any aptitude for it at all. We'll talk about this much more in another chapter, but it's important to start breaking down that wall now rather than waiting until later.

Inclination, Aptitude and Skill

As much as I shudder if I imagine myself having to work all day as an accountant, a policeman or a psychiatric nurse, there are people who have a talent for that and get genuine fulfillment from doing their job with expertise and elegance, even if they never think of their profession in those terms. I don't have an *inclination* to do those things. They don't appeal to me. I might be pretty good at them, who knows? But I don't care to even find out.

There are other activities that once tried, and finding a certain *aptitude* for it, hold an even greater attraction. As an example, I was middle-aged before I was exposed to handgun sport shooting. I was chaperoning a youth activity that had been arranged at an indoor shooting range. To my surprise, I was very good, better than any of the young men who were there or even than the military instructors who were supervising us. From that point on, it had a bigger appeal to me. I've since taken it up as a hobby and enjoy it. I'll never be a champion, but I'm good.

Obviously I had some natural aptitude, or talent, for shooting. Discovering that talent increased my inclination for it. If I had never had the exposure or opportunity to discover my talent, I still would have had the natural aptitude, lying dormant. Now that I have discovered it, I'm pursuing it, and I'm working to improve my skills in it.

So inclination can lead to discovering aptitude and discovering aptitude can increase inclination. But only work can change a talent into solid skills. Until talent has been transformed into skills, it's just a seed that has yet to be planted and nurtured. And

there's a big difference between seeds and a flower, or a fruit or a tree. The same is true in art, but art isn't the only thing a person can have a real talent in. There is a genuine craft to every profession and there will be people in all walks of life that are real artists in their particular craft, while others in the same field are merely adequate.

And for those who might be described as a genius—in whatever field—they still had to learn their craft. No one gets to the top of a mountain by *falling* there; they *climb* there.

Talent and Tangent Skills

Another basic point is that the way we grow, develop or progress in our artistic talent may not be in the way we think we do. I'll give you an example.

Learning to draw has much less to do with our hands and much more to do with our eyes. Before we can learn to draw, we must first learn to *see*. We must be able to discern between subtle shapes, sizes, angles and shadows. Then we can attempt to draw them. If we don't learn to see them, we'll never learn to draw them.

I could use a similar example with acting. Before we can portray a certain emotion, we must be able to *feel* that emotion and to discern the difference between one subtle emotion and myriad other blurred emotions that are also part of the human emotional experience.

Before we can play our music a certain way, we must be able to *hear* what makes it that way, beyond the notes. And on and on.

That may not be news to you. If not, you are ahead of the game.

Craft

The last point I'll make in this early chapter is the necessity of practice. If you have read my bio, you will know that I am proficient in a wide range of art media: oils, watercolor, pencil, and acrylic. What surprises me repeatedly is this: even though I have many years' experience with each of these media, when I try to

Talent: Everybody Has Some Talents

work with a media that I haven't used in a while, I'm definitely not at my best form. It's funny. I can remember having been much better at this than I am at that moment, but it takes time to get back up to speed.

Let's consider music, brass instruments, specifically. When learning to play trumpet, trombone, tuba, or any other brass instrument there is a certain muscle tone that must be developed in the lips. This is called "embouchure" and it means being able to make the right buzz for that instrument. Switching from one instrument to another will require an adjustment that will take time. Even staying on your own instrument and only changing the size or shape of the mouthpiece will alter the sound produced. And no matter how good you are, even if you don't change anything, but don't practice for a few days, you will still lose your embouchure.

It's really the same with all the arts. We can get rusty surprisingly fast. And when our skill level is higher and our performance more refined, we must continually hone the blade of our talent so it won't get dull on us.

It all comes back to practice. There's no getting away from it.

Success in the Arts: What It Takes to Make It in Creative Fields

8. Discover Your Talents

Definition of Talent

Even if the most important quality you can bring to your particular art form is your passion or love for it, I think it's important to discuss the issue of talent, and how much of it we have. We'll need to look inside ourselves. Self-knowledge is a good thing, especially when we're deciding our future. Some guided introspection may be helpful for you to see where you are on the road of your career path.

The word talent comes from the Latin word *talentum* which means a "sum of money," which, in turn, came from a similar Greek word meaning "sum, balance or weight." In the Bible, talent is a large unit of money spoken of in certain parables. The common thread here is that a talent is something of great worth. That is right. A personal talent is, indeed, something of great value. It can, hopefully, be financially valuable as well.

Interestingly, there are many different ways to look at the concept of talent, and it is often called by different terms. Examining some of these and looking at different ways of labelling talent may be illuminating.

Intelligence

Most of us have taken some sort of intelligence test at some point in our lives. These tests are intended to be a measure of our intellectual abilities. IQ tests have been in and out of favor with various educational jurisdictions for decades. Some people are against even having such a thing as IQ tests. Another of the

Success in the Arts: What It Takes to Make It in Creative Fields

criticisms directed at IQ testing is that it is often very narrow, quantifying only certain kinds of learning or abilities such as vocabulary, geometry, numeric skills, abstract reasoning, and so on. Considering all the possible abilities a person might have, the typical IQ test accounts for very few of these skills for summing up a person's overall "intelligence."

Howard Gardner, the psychologist, proposed that intelligence is not a single factor, but that there might be multiple intelligences in human beings. He originally listed seven possible intelligences: verbal-linguistic, logical-mathematic, visual-spatial, body-kinesthetic, auditory-musical, interpersonal communication and intra-personal communication.

This list sounds like a list of the creative arts, doesn't it? Each field of art has its primary specialty. It would seem obvious that a dancer would need a high degree of body-kinesthetic intelligence, a painter high in visual-spatial, and so on.

This can be a very straight-forward approach for thinking about careers in the creative arts. It may have been the way we thought of our abilities even if we didn't know the terms. And as mentioned in the previous chapter, it is only natural for us to be inclined to pursue things that we feel able to do, even if they are challenging.

But there are other qualities that may have a bearing on how to succeed in the arts, and less obvious ways of looking at our talents.

Personal Strengths

A few years ago I read a fascinating book called, *Now Discover Your Strengths*. Its authors are from the Gallup organization, the opinion poll people, and the book's ideas are based on some two million studies of successful people in a huge variety of professions. (Who else but the Gallup folks could amass two *million* studies!?) The major premise of the book is that successful—and happily fulfilled—people work in a way that uses their personal strengths.

Halfway through the book the reader is invited to take a twenty-minute online test to determine his or her top five strengths

out of a possible thirty-two strengths. I took the test. The interesting things about these thirty-two possible strengths is that they weren't at all what I expected: math, art, language, sports, or things like that. Instead, my top five personal strengths were: Strategic, Achiever, Connectedness, Communication and Activator.

I know those terms may not mean much to you. They didn't to me, either, until I read the detailed explanation of them, which are found in the second half of the book.

This is a very different way of listing one's talents, or as the book calls them, strengths. These strengths aren't linked to school subjects or specific occupational—or artistic—pursuits. They aren't a list of more or less common "skill sets" that we might have acquired from our education or careers. Instead, these strengths deal with the ways our minds and personalities work.

All I can say is that *Now Discover Your Strengths* was a breakthrough for me. It may also be for you as well. I recommend it only for adults, as most adolescents have lived too little on their own to have really forged the kind of patterns that the test relies on. It gave me a wonderful insight into understanding myself. This contributed to my undertaking the activities that have led me to write this book.

Dyslexia

Dyslexia is a kind of learning disability that affects between five and fifteen percent of the population. It is defined by the World Health Organization as "manifested by difficulty learning to read, despite conventional instruction, adequate intelligence and socio-cultural opportunity." Basically, dyslexics have their brains wired differently from the mainstream population.

The term dyslexia means "difficulty with the lexicon" or problems with words. Dyslexics have difficulty learning to read even though they are no less intelligent than non-dyslexics. They often have other difficulties, which the normal world doesn't usually have. But dyslexics are often multi-dimensional thinkers, highly creative and intuitive. Creative fields are particularly attractive for them because they provide an area where dislexics may excel.

Success in the Arts: What It Takes to Make It in Creative Fields

A surprising number of famous people have been diagnosed with dyslexia (some posthumously, from the careful study of the evidence of their lives). Here is a sampling of persons claimed to be dyslexic on a popular website on the subject dyslexia: Albert Einstein, Pablo Picasso, Winston Churchill, Henry Ford, Walt Disney, Earnest Hemmingway, Vincent Van Gogh, Nelson Rockerfeller, Michelangelo, Mark Twain, Steven Spielberg and Steve Jobs.

As you can see, dyslexia does not prevent high achievement in a wide variety of fields.

I am dyslexic. Whether you are or are not dyslexic is not the point of bringing this up. Dyslexia, in and of itself, is not a talent. Nor is not having it. The point is that we are all dealt certain cards to play with in life. But equally important, or maybe even, more so, is how we play our hand.

Nurture or Nature?

Some people believe that talents are innate, inborn, a result of your genetic makeup or metaphysical persona. They cite studies of identical twins separated at birth, which showed a remarkable correlation of abilities and personality traits. Those studies certainly have proven something, but exactly what is open for debate. Those views also imply that you're dealt a certain set of cards and that's all the cards you get until the game is over—which is unlike any game I've ever played—and unlike life as I have experienced it, as well.

I see our talents as a more dynamic part of our life. I feel that our inventory of talents is influenced by our circumstances, but more especially by our efforts. As I have taken great pains to point out, I believe I began life with a very modest endowment of natural talent for visual art. Maybe above average, but not as much as most people entering the profession. I did, however, have a very great love of the magic of creating art. That love of art has propelled me forward to grow in my abilities, skills or talents. If we consider talent an ability to do something, I have grown in talent to a point where I have had a successful career.

And so can anyone else who wants it bad enough.

9. Models of Talent

Before going on to other thoughts, we need a bit more exploration of the issue of talents.

The Soil Model

Some people visualize talent as a plot of ground on which you can plant seeds. In this model, some persons would be endowed with vast acreage while others might only have a small plot of ground.

One of my best recollections of living in Japan as a child was seeing a small but exquisite traditional Japanese garden. My father admired how even the poorest of Japanese farmers, who might have landholdings measured in feet instead of acres, would still manage to have a personal garden perhaps only one or two square yards, in which every plant, every rock, every bit of moss was placed just so. Twigs would be bent to the specific forms desired. It would be a miniature world of beauty and harmony.

If you accept the Soil Model of talents, it still shows that a person can, with a very small bit of land, achieve something that might touch one's heart more than the expansive field with combines harvesting it. It's not so much a question of value as it is of intent. At the same time, who could say that the immense agricultural accomplishments of our food supply are without merit? In Japan, with its large population and naturally confined island limitations, land is at a premium. It should not surprise us that land in Japan would be respected and well used. However, I have never heard of a rich Japanese immigrant who bought five hun-

dred acres of Kansas farmland to landscape Japanese style. It just doesn't make sense. The two don't go together well.

So if talent is like land, the best we can hope to do with our territory is to make it fruitful. But different land is suited for different crops and uses. They don't grow many oranges in Ohio, and the soybean industry doesn't rely on the Florida crop, either. And yet both states have lots of prime agricultural ground.

What can this tell us regarding talents? Maybe we should take a closer look at what our talents are and where we might best employ them. Many a young person makes a decision to follow a certain path because of hero worship: a great actor or musician or artist has influenced him or her. Being touched by the power of a particular kind of art is a necessity for following that art. But appreciation for a given art form doesn't necessarily mean we're cut out to practice it on a professional level.

Does that go against the whole thrust of the personal story that fills most of this book? Am I being a hypocrite? Wouldn't be the first time.

Maybe I'm just offering a belated word of caution here. Be sure you're planting the right crop in your particular soil—or choosing the right career for your particular talents. Mark Twain said, "We are always more anxious to be distinguished for a talent which we do not possess, than to be praised for the fifteen which we do possess." This may be a manifestation of the grass-is-greener syndrome to which we are all susceptible at one time or other.

Regardless, the Soil Model of talents is interesting, but I don't really feel that it is the most helpful way to look at talents, anyway.

The Seed Model

A different model for looking at talents might be the seed model. In this model, each person starts life with some seeds, some food crop seeds, some flower seeds, and maybe even some grass or weed seeds.

I don't know any farmer or gardener that really appreciates weeds, but to look at a lot of people's lives, you'd think weeds

Talent: Models of Talent

were the most valuable kind of seeds that exist. Some folks seem to plant and nurture their weed seeds and not do much with their best seeds, don't they? This part of human tragedy is such a shame. Let's just agree that we don't want weeds.

While many individuals appreciate a nice, healthy lawn, others might prefer a well-tended flower garden. Still others might value most the food crops, like wheat.

A healthy wheat plant can have twenty to forty kernels grow from a single seed. A person starting with just one single wheat seed and keeping all the grain harvested to plant the succeeding year would have between 160,000 and 2,560,000 grains in just five years!

If we cultivate the seeds or talents given to us, we will have more seeds or talents, a net increase. And not just of the variety we planted, but seeds of new kinds as well. It has fascinated me that unlike real horticulture where an apple seed will only produce an apple, using our talents seems to grow, not only the talent we planted, but new and different kind of talents as well. It's as if we planted our apple talent seed, nurture the tree really well and sometimes we harvest more apple talents—and a few pear talents and orange talents as well.

Conversely, if we don't plant the seeds or talents given to us, we might maintain what we have, but more likely our abilities will dwindle due to natural deterioration. Use it or lose it. It's true in agriculture and also in developing our talents.

The biblical Parable of the Talents (even though the word talent here means a sum of money) clearly extols the persons who use their talents to get more and condemns the person who, out of fear, was too cautious to venture forward.

In this Seed Model, a person with very modest amount of natural talent might be able, through diligent cultivation, grow considerably in ability. Brendan Francis Behan said, "If you have a talent, use it in every which way possible. Don't hoard it. Don't dole it out like a miser. Spend it lavishly like a millionaire intent on going broke."

Success in the Arts: What It Takes to Make It in Creative Fields

So what is the moral of all this? Talent is not a static thing. It is influenced by what we do with it. I agree with the actress Sophia Loren, who said, "Getting ahead in a difficult profession requires avid faith in yourself. That is why some people with mediocre talent, but with great inner drive, go much further than people with vastly superior talent."

Why Worry About It?

So, if it is true—and I deeply believe it is—that your talents are dynamic in that they can shrink or grow depending on the effort you put into them; and if it is also true that exercising your talents may give you new and different talents that you didn't have before, then, why worry about how much initial talent you have anyway? Many beginning artists—and some well along in their careers—agonize over how much and what kind of talent they have. It really is a fruitless endeavor. It is more likely to grow more seeds of self-doubt than seeds of talent.

It might be best to stop gazing at your navel and dive right in. Stop stewing about how much talent you have and get to work! Study your craft. Labor at it. Watch the masters of it and learn from them. Ponder it and meditate on it, but don't fret about it.

Talent: What is Creativity?

10. What is Creativity?

Much has been written and spoken about creativity. A lot of it is dry academic stuff and uses big words and obscure concepts to describe this most intriguing thing called creativity. There's a fair bit of folk legend on the subject, too. Some of those ideas on creativity are as fanciful as frog feathers. I'm not claiming that frog feathers aren't real, maybe they are. All I know is that frogs of my acquaintance have no feathers. Likewise, many of these notions about creativity are quite different from my experiences.

Let's look at this subject anyway.

What Creativity Isn't

Sometimes it helps define something by eliminating things that are confused with it. That exercise will be particularly useful in our discussion of creativity. Let's dispel some myths.

MYTH #1: CREATIVITY IS DOING WHATEVER COMES INTO YOUR HEAD. While it is true that there are brainstorming techniques that do just that, elicit anything that pops into the participants' minds, this isn't the basis of true creativity. We'll come back to brainstorming later.

MYTH #2: CREATIVITY IS DOING WHATEVER YOU WANT. There has been a culture of elitism that would have you believe that this is so. It originated in Renaissance times. It became accepted to give special license to supposedly creative people. It was a concept of celebrity status that considers these artistic folks were somehow above the average person and above the normal rules of conduct.

Success in the Arts: What It Takes to Make It in Creative Fields

Michelangelo was certainly one of the greatest artists of the Renaissance. Unfortunately, he really bought into this notion of artistic entitlement and milked it for all he was worth. A very talented artist contemporary of Michelangelo's, named Raphael, used to poke fun at him for his anti-social ways. Raphael even painted a large fresco titled *The School of Athens*, which shows Plato and Aristotle (the image of Plato is thought to be a portrait of Leonardo da Vinci, who Raphael admired) as well as other great philosophers and artists. He painted himself and a few of his artist friends in a little group of people at the side of the scene. Front and center in this fresco he put Michelangelo, sitting on a step and sulking. Raphael, who was an excellent artist himself, had very little patience with Michelangelo's putting on "artsy-fartsy" airs.

Unfortunately, we still uphold the same artists-are-different delusion today. It's a notion fostered by self-indulgent persons who want license to act badly. Sadly, it is well-engrained in our society, but it ought not to be. Creativity is no license to be self-centered, selfish or rude, any more than being wealthy or famous should give folks license to be boorish.

MYTH #3: CREATIVITY JUST HAPPENS WHEN YOU ARE INSPIRED. The ancient Greeks believed that there were goddesses, called the Muses, who gave artists inspiration. The word inspire means to "breathe in" or "inhale," and the word inspiration originally meant to be "breathed upon" by the gods.

Many people today may not believe in literal muses, but they still believe that creativity involves waiting for "inspiration" to light upon our shoulders and give us ideas. The notion that the truly creative individual can only create when "in the mood" is both undisciplined and untrue and is the battle-cry of the lazy and under-achievers. The real creative geniuses of our world worked at their art, whether they were in the mood or not. Thomas Edison said, "Genius is one percent inspiration, ninety-nine per cent perspiration."

MYTH #4: CREATIVITY IS JUST BREAKING THE BOUNDARIES. That is the shallowest myth of all. Just breaking boundaries serves little

purpose in and of itself, unless it solves a problem. To be sure, many a creative solution requires a new approach, but a new and different approach just for its own sake doesn't constitute a creative one.

What Creativity Is

In the final analysis, creativity is the ability to solve problems. There. That was easy.

That's really what it's all about.

When you have a problem there are always constraints, limitations and boundaries that come as part of the problem. Part of creativity is having clear vision to correctly perceive a problem and the constraints around it. That vision will also see real limitations as separate and different from imagined limitations.

Let's say you've got a glass jar with a metal lid that won't unscrew. You could smash the jar to separate the lid from the jar, but that's hardly a creative solution. Nor is it a suitable solution. One of the real constraints of this problem is that, most of the time, the jar needs to remain intact after it's open or its contents would be ruined if mixed with broken glass.

A creative solution might be that you pry a bit all around the edges of the lid to break the seal it has on the jar. You could run some hot water over the lid, but not the jar, to get the metal lid to expand a bit more than the jar and loosen up. You could wrap rubber bands around the lid and around the jar to increase the traction of your grip.

Some people think that a solution must be new and different in order to be creative. How superficial. Being new and different is not the necessary ingredient. Solving the problem is what is necessary. (By definition, "new and different" has already been done.) So don't worry about it.

Brainstorming

A useful technique for generating new ideas is called Brainstorming and originated in the advertising world. Basically, a small group of people assembles to brainstorm on a particular

problem. Ironically, this very free-form creative tool has some rules. (Do we see a pattern here?)

Rule 1: Set a time limit. Ten minutes, fifteen at the most. The goal here is to create a mood of heightened spontaneous thinking and a bit of abandon. That can't be maintained for a long time.

Rule 2: A facilitator helps the group achieve a clear understanding of the problem or issue, encourages participation, reminds (if necessary) that there is no criticism allowed and writes down ALL responses. An association map is best used for this.

Rule 3: People say whatever comes to mind.

Rule 4: No comments or judgments whatsoever are made on any ideas put forth.

Rule 5: No one owns an idea. All ideas are equal. Build on other's ideas or offer contradicting ideas. No egos, establishing positions or ownership.

Rule 6: Quantity is better than quality here. Just get as many ideas onto the table as possible.

Rule 7: Everybody contributes. No shrinking violets or quiet considerers welcome.

After the brainstorming session, some grouping of ideas can be done. Writing the individual ideas on small papers and allowing the participants to arrange them into groups is helpful.

Brainstorming is a procedure, but it's also a state of mind. A person can learn to brainstorm with oneself. The same rules apply. Be sure to withhold judgment and write down, sketch or record all the ideas.

Thinking Outside the Box

Brainstorming, in and of itself, isn't creative. It is the next step is where real creativity is exhibited. Either with a brainstorming session or even in solitary solution finding, after the possible solutions are generated, someone has to consider the ideas generated to see what emerges as viable. Ideally, whoever does this should have the flexibility to not reject new and different approaches by reflex. The examiner(s) must seriously consider each

Talent: What is Creativity?

idea and assume, initially at least, that each one has merit. Even the most outlandish ideas should not be discarded out-of-hand, but given real consideration. Often a genuinely successful solution can be discovered by entertaining non-traditional ideas. But not just because the idea was non-traditional.

When the Linux group was considering how to keep from being swallowed up in the Microsoft world, someone suggested, "Let's make it free." A crazy idea, but they did it.

3M made a new adhesive that didn't stick very well. Instead of discarding it, they built a whole industry on it. And the Post-it Note™ was born.

Using Your Back Burner

My father was once a chef at a large resort in Maine. One dish that made him a bit of notoriety was his Chicken Imperial. This was the most expensive dish on the menu. Professional restaurant reviewers raved about it. Here is his closely guarded secret.

He bought old stewing hens at the market, put them in a big pot with some onions, a bit of wine and shoved the pot on the back burner of the big stove and cooked it slowly for two to three days. Yes, days! After that the two chunks of breast meat fell off the bones of each chicken as complete pieces and were carefully wrapped and frozen. The rest of the chicken meat was picked off for chicken salad. The remaining broth stayed on the back burner for another few days and was rendered down into an incredibly savory sauce. This was also carefully packaged and frozen.

A customer ordered Chicken Imperial; a frozen breast and a portion of frozen sauce were micro-waved and, voila! Chicken Imperial.

What was his secret?

Time. Not thyme, but time.

So it is with creative projects. Once we get fully engaged in solving a problem, our brain naturally starts to work on it. We can walk away from it, even turn to other pursuits, and we may think we've stopped working on the problem. But we haven't. Our brains have a Back Burner, too, and it will still be cooking

57

away on the problem. We might call it our unconscious mind, but whatever the name, it's very real. And it's very powerful.

Albert Einstein understood this principle when he said, "As one grows older, one sees the impossibility of imposing your will on the chaos with brute force. But if you are patient, there may come that moment when, while eating an apple, the solution presents itself politely and says, 'Here I am!'"

I can't tell you how many times I've had a beautiful solution to a problem come percolating up to the surface almost "on its own" when I wasn't consciously working on it. If I've gotten engaged in my creative problem early enough, I may be able to use that wonderful solution. If I got started on my creative problem too late, the solution might have come after I've already finished the project or committed to an earlier and less inspired solution. You may have experienced this as well.

The moral of the story is: get engaged deeply in your creative problems as early as you can and take advantage of your Back Burner. It's free and it works all the time.

Section 3:
Smarts

Success in the Arts: What It Takes to Make It in Creative Fields

Smarts: Using Your Smarts

11. Using Your Smarts

Remember the three qualities necessary for success in the arts? Those qualities were 1) talent, 2) love of the work, and 3) a cleverness about what you can't handle head-on. That quality could be called "smarts." Sometimes you can't tackle what's coming at you and you have to run around it. That happens in football all the time, so much so that the phrase "pulling an end-run" has entered general usage. (Thanks to computers, we also have a "workaround.")

I never played football. But I knew some people who did. With the big padding all players look like they are gigantic and bulky guys. But lots of quarterbacks are of modest build. Receivers are often slight of body so that they can be fast on their feet to keep from being squashed by those big bruisers on the other team's line. They don't make goals by straightforward application of brute force; their job is to avoid and circumvent their obstacles.

I have noticed that some illiterate people are very shrewd about how they avoid revealing their secret. With that kind of demonstration of ingenuity and intelligence, it's a shame that so many don't believe in their own ability to learn to read.

I knew people in school who would be extraordinarily resourceful in discovering ways to cheat. If their dishonesty weren't so shameful, you'd almost admire their creativity. If they had only put that much work into studying, they could have been both honorable and educated.

In the case of the illiterate, they've convinced themselves that they can't read and instead work creatively to fool the world oth-

erwise and to cope. In the case of the football receiver, they really can't plow through their opponents and must avoid contact to succeed. The common thread is that when people put their minds to it, they can get by in the face of obstacles, and maybe even do well.

So it is with pretty much any of the arts. We have to know what we can do straight out and what we must skirt around. Some people's careers have been based heavily on smarts. Elvis once quipped, "I don't know anything about music. In my line you don't have to." He knew the secret of his career lay not in musical training, but by his charismatic performance.

Isn't it amazing that Louis Armstrong, with a voice no one could call beautiful, recorded so many records and sang with so many people with truly great voices?

Look at how many movies Arnold Schwarzenegger made and how much he was paid with very modest acting talent! Even in his early career, when he was still doing nothing but action movies, reporters were often amazed at press conferences and junkets by the degree to which Arnold would go out of his way to win their goodwill and approval. His talent wasn't in acting; his talent was in relationships and self-promotion. But he had something that worked at the box office, too.

Andy Warhol had his fifteen minutes of fame largely by manipulating photos of famous people and silk-screening their images into art. If you call that talent, it was meager in my estimation.

Now, don't get me wrong. I actually like the work of all three of these artists, but I'd be reluctant to call any of them highly talented, at least not in the traditional sense. So, what made them succeed in spite of some real talent deficiencies?

Part of it was smarts, knowing how to use what limited talent they had in such a way as to make something that touched a chord in the minds of the public. It also involved using other talents different from the mainstream talents expected of someone in their respective fields. We are all composite beings, made up of a unique combination of abilities and limitations. Using as many abilities as we can will lessen the effects of our limitations.

Exercised over time, employing as many of our talents as we can will actually lessen the effect of our limitations.

Learning Tricks

As for me, my original talent deficit was in certain drawing tasks. Then I learned to trace from photographs and capture the shadows that make up an image. Interestingly, in doing that I began to see shadows in real life better and also learned to draw better when not tracing.

In one sense of the word, tracing was a crutch to help prop up my weak drawing. Tracing helped me see the forms and shapes better. But I needed to learn to draw without tracing, too. You have to know when to leave the crutch behind and walk on your own, or else you will be a perpetual cripple.

That's hard. Because tracing is quicker than drawing with only hand and eye, the temptation is there to use it all the time. I have had to learn to wean myself from tracing. One way that I have learned to work without tracing from photos is to draw freehand and then use a tracing paper to trace a new improved version of my own drawing by moving some elements, shortening or lengthening others. Sometimes I used two or more stages of tracing, "working up" the image.

This technique is not unlike the one used in traditional figure drawing classes where a quick and light gestural drawing will serve as the foundation for a more defined figure drawing. Our first lines help us see where the next ones need to go.

I have seen trombonists use an extended finger to brush against the bell to let them know when their slide was extended a certain distance. My wife, who used to play the trombone, said it's a bad habit that will hold back a player eventually.

Sometimes people in the arts use gimmicks to get recognition. The old show-biz adage counsels, "If you don't have an act, you'd better have a costume."

Of course, in reality, if you don't have an act, a costume can't make up for it. Still, many less-than-stellar talents have had rea-

Success in the Arts: What It Takes to Make It in Creative Fields

sonable careers in the creative fields because of a quality that can benefit any of the arts: showmanship.

Those people who say, "you can't judge a book by its cover," never had to sell very many books, that's for sure. It's human nature to be influenced by the package. To insist otherwise, that we ought to only be concerned with what is inside a person is just going against all reality and sticking one's head in the sand like the proverbial ostrich.

The author who is willing to get out there on the radio talk shows will do better than the one who prefers the solitude of the writer's garret. That performer who is willing to socialize will garner more business than the one who leaves all the schmoozing to an agent. The performer who is willing to do a charity event will make contacts that just might not be made elsewhere. It's all part of "strutting your stuff."

All arts have these kinds of tricks, costumes and outward packaging. It is to your advantage to find them and learn them. It's not cheating if you don't use them perpetually as a crutch, but as a tool and a learning aid.

The Cycle

I wasn't totally without gifts in art. In other areas of my image-making I had some natural aptitude and abilities. Colors were something I loved and felt at home with. I could learn wonderful things about color interaction just from looking at a Van Gogh or some other artist's work. Those things stayed in my head. It's as if there was already a place in my mind for the new information. The new knowledge felt at home right away.

I think that's the way it is with all of us. Some things come easily and some things have to be learned by sheer brute force or repeated exacting study and work.

The important thing about using your smarts is to not get satisfied with the tricks you pick up along the way to help you get by, but to actually grow from them. I believe it is possible to increase in our talents, but they don't grow on their own. We must press

ourselves so that what we achieve by learned technique at one point becomes internalized and instinctive in the future.

And so, smarts feeds on heart, our love of the work, our unwillingness to sit still. And both smarts and heart will contribute to the growth of talent. That, in turn will encourage more heart and so on. If this were a weakness or defect we'd call it a "vicious cycle." I prefer to call it the "artistic cycle."

Don't plateau. Don't be trapped by your successes. Use a trick to get yourself out of a tight spot, then thank that trick by skinning it alive and seeing what makes it work. You know one thing today. Know more tomorrow.

Josh Billings, a contemporary of Mark Twain, said, "It ain't what a man don't know that makes him a fool; it's the things he does know, that ain't so." So challenge your ideas, too. They are often more influential to you than physical abilities.

Seek a Mentor

Another part of smarts is knowing that you can't learn it all by yourself. Or, at least if you do, you'll end up knowing very little. We need to have someone, or better yet, several someones, who are farther along the path and are willing to help and to teach us things we don't know.

A friend's little sister was being taught to swim by her dad. She had a nice floater around her that held her up nicely. After an initial lesson in the water her dad left her for a moment and went to the side of the pool to talk to someone. The little girl panicked, afraid she was going to sink. She was on the verge of getting frantic when her dad came back, and gently taking her thrashing feet guided them to the bottom of the kiddie pool they were in, which was in easy reach for her.

That's what a mentor can do for you. He or she may be able to show you abilities that you already have, which can be used to solve whatever artistic challenge you face. You may find that some of these solutions are in easy reach, and others will cause you to stretch a bit. But that's alright, too.

Success in the Arts: What It Takes to Make It in Creative Fields

Cultivate Challenging Peers

A few years ago in our graphic design program where I teach, we had one group of students with three very talented fellows. We called them "The Three Musketeers." They helped each other, but they also challenged each other. They ended up being a wonderful catalyst for the entire class.

Contrast that with this story. A certain kind of caterpillars have a very keen sense of smell and can unerringly find food if it is near them. In the wild they also have a tendency to follow each other, in single file, to the next food source.

An experiment was done in which the caterpillars were placed on the rim of a flowerpot, snout to rump in a continuous circle. They began to move around the flowerpot in steady progress, each following the one in front of it. A fine supply of food was placed in the middle of the flowerpot, well within their smelling range and easy to get to. But instead of going for the food, the caterpillars continued to follow the leader until one or two died of starvation. Then some of the survivors finally broke formation and found the food.

Make sure that your peers are not the kind who keep you going in circles, but the kind who challenge you to new heights. Surround yourself, not with folks who make you feel completely at ease, but ones who will make you stretch.

Whatever your main impetus for improvement is, be sure that there is really some progress being made. Albert Einstein pointed out that "Insanity [is] doing the same thing over and over and expecting different results!" If your peers, mentors or tricks aren't helping you grow and improve, you need to do something different, even if it's just cultivating new peers, mentors or tricks. Clarence Birdseye, inventor of frozen food, said, "Go around asking a lot of damfool questions and taking chances. Only through curiosity can we discover opportunities, and only by gambling can we take advantage of them."

Staying in the same place for too long isn't smarts, it's stagnation.

12. Conventions, Rules and Principles

My first year teaching at St. Lawrence, I was counseling with a student about a project of his. I told him that his approach wasn't working. I could see that plainly. It looked amateurish. He asked me why.

I didn't know why. I just knew that his approach wouldn't work, and I told him so. But I also knew that my answer was totally unsatisfactory. I vowed that day to learn the whys of good design, not just the whats. It's not enough to just say "this is good" and "that is bad." What are those values based on? If it's based on current fashion, that's very temporary. What are the reasons that are more enduring than fads? What are the underlying Principles? Once you can see those, the rest becomes so much clearer.

What's the difference between principles, rules and conventions?

Conventions

There are thousands of practitioners of your art who are already practicing. They've spent countless collective years performing in their art and genre and have learned a few things from trial and error. You can learn a lot from these folks even if they are not your mentors or your peers. They make up your profession. To think that what you personally want to accomplish is so new and radical that you have nothing to learn from your industry as it stands now is the height of vain pride.

Conventions are the way other contemporaries of your art practice their art. It includes what is fashionable in a given era. It is

Success in the Arts: What It Takes to Make It in Creative Fields

what made baroque music different from classical, and classicism different from romanticism. And even though music is currently fragmented into many camps such as R&B, blues, fusion, techno, new age, punk and on and on, there is still a current convention of the way things are done in each particular genre. Old punk is not the same as current punk, and so on.

By the very nature of conventions, they are temporary, evolving ways of practicing the art form. We could also call it fashion or fad, style or trend. There's much to learn here and I recommend that you learn as much as you can.

Rules

But don't stop there. Go deeper. What are the rules? Rules are easy ways of dealing with specific situations. They are based on principles and help you make quick decisions.

Here's one: Chekhov's Gun Rule. Anton Chekhov, the great dramatist, said that if you bring a gun on stage in act one, by act three it had better be shot. Chekhov's rule is seen used over and over in movies and literature. Frodo Baggins in Tolkien's *Lord of the Rings* is given a vest of impenetrable mithril early in the story and later on it saves his life, just after we forgot that he had it. James Bond is loaded up with gadgets at the beginning of every mission and uses each one throughout the story.

This rule is artfully broken in mystery novels to misdirect us and have us suspect the wrong person as the villain.

The important thing is that you can't skilfully break a rule that you don't know. And so it behooves us to learn all the rules of our particular art form, even if we wish to break them. Unfortunately too many young artists are anxious to break rules, sometimes even before learning them. Moreover, it is just a token of pitiable immaturity to want to break rules just for the sake of doing so.

Rebellion for its own sake isn't edgy or groundbreaking; it's tired and hackneyed, and no more original or creative than the adolescent hormones that produce those feelings.

You may, indeed, set your art world on its ear once you get a few breaks. But be humble and learn what you can from those

Smarts: Conventions, Rules and Principles

who are actually working artists in your field. They may do their art not only very differently from how you now practice it, but also very differently from the way you *want* to practice your art. Still, be patient and learn now. What you will see is that the best of the current conventions in your world of art are in harmony with not only rules and conventions, but also with common sense.

Some young artists are afraid that they will be contaminated by the "old guard," and they want to pursue their vision in the purity of childlike ignorance. They feel education will "ruin" them.

Look at Vincent Van Gogh. He was hugely influenced by Millet, Gauguin, Pissarro and dozens of others, but was different from them all.

Picasso is remembered for his many experimental styles but he was a master of conventional styles before he branched out. He didn't start out forging new territory.

If you have something that is uniquely worthy within you, education will not spoil it. Instead, learning will free it for you. It will open you to greater inspiration and accomplishment, not less. Ralph W. Sockman said, "The larger the island of knowledge, the longer the shoreline of wonder."

Principles

And what are principles? They are more than rules and temporary conventions. Principles don't change with styles or fads. Styles and fads come and they go, but people always end up gravitating to the true principles of each art form. Principles are the foundation. Recognizing them may come when someone points out why one approach works for a particular purpose and another doesn't.

Principles are the things about any art form that are eternal. They are the things in common between the music of Mozart and the work of Lennon and McCartney. They are the same qualities that resonate between the paintings of da Vinci and Paul Klee. Principles are what makes brothers out of characters as diverse as Victor Hugo's Jean Valjean and Orson Scot Card's Ender Wiggin.

Success in the Arts: What It Takes to Make It in Creative Fields

Fads come and go. History would teach us that the artistic and educational powers-that-be are not great judges of what works of art will become immortal. I submit to you that those works of art that survive generation after generation do so because they embody some eternal principles of their art form. They are good places to study if you're trying to discover principles.

Don't be too quick to label something a principle. These are the bedrock, the timeless things of your art form, not to be confused with your personal taste and preferences. They are not the same things as conventions and rules. Conventions will change and evolve over time and rules can be broken. But not principles. All you can do is break yourself or your art against principles. They don't budge. Ever. They are immutable, unchangeable.

I'll give you an example of a true principle having to do with color. First some background. Color is distinguished by three different qualities: hue, saturation and value. Hue is the difference of colors around the rainbow: red, orange, yellow, green, etc. Saturation is the purity of the color as in the difference between a pure red and a dusty rose. Value is the lightness or darkness of a color such as yellow is lighter in value than blue.

Now with that brief primer in color, I'm ready to give you a principle that I discovered. It is this: when combining color elements in a composition, to get legibility, such as with type and its background, the only color quality that matters is contrast in *value*. That's the principle. It never changes. It's not dependant on personal taste or fashion. It's an unchanging truth about color.

It won't matter too much what hue difference there is between some type and its background. You could put red type on a green background and the type will be largely illegible if the values of the red and blue are too close. It also doesn't matter if one element is very pure (saturated) and the other is very dull (neutral). If the values of the two different elements are similar, you won't get good legibility. Ever.

People may be able to carefully discern what you're showing with close examination, but if seen from a distance or at a small size, the elements will be quite illegible.

Smarts: Conventions, Rules and Principles

Unfortunately, many practioners of graphic design have never learned this principle. Prove this to yourself by looking through a few dozen tiny book covers on Amazon.com or some other online bookseller. Some of the titles or subtitles will be very hard to read not just from the small viewing size but because those designers broke the principle of contrast of value. I repeat, you can break a rule, but you can't break a principle without ruining your art.

I apologize to those of you who have very little background in visual art, as you probably didn't appreciate much of that. But that brings us to another point that needs explaining: unlike many things we're discussing in this book, principles are most likely to be particular to your chosen art form. As a result, I can only give you concrete examples in my area of visual art.

But each of the arts has these principles that you need to discover. The focus of this book isn't to deal with the principles of dance or music or drama, etc. It is to deal with the principles of success in the arts in general, as it says in the subtitle, *What It Takes to Make It in Creative Fields*. In this book we are concentrating on principles that relate equally to all the arts.

You may feel lucky to discover a few dozen of these principles in your whole career, but the search is worth it. They are "pearls of great price."

Seek after principles and you will find ways for your work to have the potential to be immortal.

Popular Art or Purist?

During his lifetime, Charles Dickens was dismissed by the intelligentsia of his day as nothing more than a hack. After all, he wrote his stories in installments, published in newspapers. But I ask you, who are the authors that were critically acclaimed in Dickens' day? Have any of us ever even heard of them? No. Why, then, has Dickens' work lived on while their work has faded to obscurity?

In fact, Dickens novels have never gone out of print since they were written. What other works from that era can claim that? This

71

Success in the Arts: What It Takes to Make It in Creative Fields

year alone *Oliver Twist, A Christmas Carol, David Copperfield, A Tale of Two Cities* and *Great Expectations* will each sell more copies than many current author's who impress the critics. Today's literati, as did those in Dicken's day, would still heap criticisms on him for being too sentimental and for having characters that were too grotesque.

But Dickens had something in his work that touches people deeply. Karl Marx said of Dickens that he "issued to the world more political and social truths than have been uttered by all the professional politicians, publicists and moralists put together. . . ." The same could be said of his grasp of the truths of writing. So, if you want to tap into some principles of writing, study Dickens. Many modern writers show influences of Dickens in their work such as Tom Wolfe, Anne Rice and John Irving.

Similar observations could be made of Mozart's work compared to those of Antonio Salieri. The latter's work has only recently had a resurgence of interest due to the somewhat fictionalized rivalry portrayed between him and Mozart in the popular film "Amadeus." By contrast, Mozart's work has been played, studied and loved for over two centuries.

And who will be remembered as the most important composer of our time? I submit to you that it is not going to be the favorite darling of the high-brow music world now, but someone whose work is often dismissed by many of the serious critics. I would guess it will be someone like John Williams, composer of dozens of film scores like *Star Wars, Harry Potter* and *Schindler's List.*

I know, it's pop music. But what makes that bad? Albrecht Durer's woodcuts were made to allow the masses to own a piece of art. Does making something for the popular public mean it must be devoid of genuine value?

At the same time, does work have to be accepted in one's lifetime to be worthy? If so, we would dismiss Vincent van Gogh's *Starry Night* as insignificant.

And so we see that we have two camps. Those who please a larger audience and find pleasure in that and those who pur-

Smarts: Conventions, Rules and Principles

sue their own agendas. The pop artists may think that the more personally driven artists are a bit too anal. Conversely, the artists who will not seek popular acceptance may think that those who do so are prostituting their art.

This is exemplified in the late Mickey Spillane's snappish taunt, "Those big-shot writers could never dig the fact that there are more salted peanuts consumed than caviar." As far as he was concerned, "If the public likes you, you're good." And he did have a point when he said, "I'm the most translated writer in the world, behind Lenin, Tolstoy, Gorki and Jules Verne. And they're all dead. . . ."

We've already discussed the dangers of trying to please everyone and the ultimate impossibility of actually doing so. Still, popularity is an issue. Some people crave it and some shun it. There are pros and cons with both camps. The high-cultured persons look down their noses at those who like trendy art, (and music, film, writing, and so on). Those who like the popular arts think the other group is insufferably stuck-up. Snobbery swings both ways. Each camp feels that they are being truer to art than the other folks.

You will make your own choice about which side of the tracks you'll walk on, but remember that the tracks lead in the same direction toward personal expression and both approaches have their good aspects. Try to be tolerant and even appreciative of the other camp. You'll be richer for it.

Success in the Arts: What It Takes to Make It in Creative Fields

13. Getting the Breaks

Luck or Leverage?

Let's see if you can pick out a common sentiment or moral in these four quotes:

- "Opportunity is missed by most people because it is dressed in overalls and looks like work." (Thomas A. Edison)
- "A wise man will make more opportunities than he finds." (Sir Francis Bacon)
- "I'm a great believer in luck, and I find the harder I work, the more I have of it." (Thomas Jefferson, attributed)
- "A pound of pluck is worth a ton of luck." (James Garfield)

So, what did you come up with?

Me too. There seems to be a very high correlation in these people's minds between work on the one side of the equation and luck or opportunity on the other side. And I believe it, too. You can't sit at home and wait for a phone to ring. That's not how anybody ever got "discovered."

So getting out there and strutting your stuff is not just an option, it's the plan. It's the only one that works.

Have you ever noticed how we tend to think that successful people whose work we don't appreciate "must have been lucky," and yet, those people whose work we do value have all "worked hard" for their success? Hmm.

Get Out There

Some people prepare forever and never get on with it. You must prepare, to be sure. Preparation is essential. No industry wants an individual who is not prepared. But there's very little point in waiting until your work is "good enough" before being

Success in the Arts: What It Takes to Make It in Creative Fields

willing to let others see it. It's not preparation if it's perpetual. That's hiding from rejection and a kind of cowardice. You need to guard against that, too.

Most artists never feel one hundred percent good about anything they do. Lots of amateurs do, though. Real professionals always want to improve. An old saying says, "Works of art are never finished, they're just abandoned." So, if you're a real artist and you wait until your work is "good enough," you'll *never* show it to the world.

What a waste!

Henry Van Dyke, author, educator and clergyman, said, "Use what talents you possess: the woods would be very silent if no birds sang there except those that sang best."

Underestimating Your Profession

In my building I had a conversation with one of our janitors who knew I was a professor of graphic design. He told me that he was going to start a graphic design business. "I've bought a computer and *now I can choose fonts.*" I was speechless. He obviously thought that there was nothing else to graphic design than choosing fonts. Is that all he thought we taught our graphic design student for all those years? If there wasn't a lot to learn, why does it take years to complete the program?

He went on, "I designed myself a brochure and used *twenty-eight* fonts in it." He was proud of it. I was shuddering.

We tend to underestimate those arts we haven't tried to truly master. That's why Thomas Mann said, "A writer is a person for whom writing is more difficult than it is for other people." The how-hard-can-it-be feeling is more common on the outsider's side of the fence than from the practitioner's side.

We, too, may be guilty of this, especially at the beginning of our careers, by thinking that getting to the top should be simple. This kind of naiveté is common to beginners. This gullibility is coupled with enthusiasm in the beginning, an important quality. The trick is to let our outlook mature and recognize the long climb ahead of us without loosing our youthful zeal.

Work Your Plan

Working your plan presupposes that you have a plan. Unfortunately, most people's plans are woefully short-sighted. That's OK. Yours will likely be short-sighted, too. Being shortsighted is just a function of our relative ignorance as beginners. That doesn't mean we should forgo having a plan. It also doesn't mean that we need to set our goals low.

What typically happens is that beginners set grandiose plans, get a little more educated and realize that their plans require a huge effort. Then they slacken their plan instead of gearing up to make that huge effort.

What matters is that you not only have a plan, but that you also work the plan. Having a plan does something for you that is hard to define, but it makes a big difference. It will do something to your attitude that's important when your opportunities come. Chances are, your big breaks will come to you in moments when you're working outside of or above and beyond the plan, but working the plan still is important

Langston Coleman said, "Luck is what you have left over *after* you give one hundred percent." Amen to that.

All of the creative fields are flooded with people, all seeking success and many who want it very badly. What makes you think that giving less than one hundred percent qualifies you for success when there are tons of folks who are giving their all to make it? "Giving your all" is the basic cost of admission. It's after that when the breaks usually come.

In the arts "good enough" is *not* good enough.

The Art of Sacrifice

Most of us know, even if we don't like the thought, that personal sacrifice is necessary for any substantial accomplishment. It's like buying some significant purchase. If we want a fancy car or a really good sound system, we know that we have to pay for them. Even though we know that there are lots of other things we could purchase with that money, if we *really* want those items we buy them, and willingly fork over our money to get them. Do we

Success in the Arts: What It Takes to Make It in Creative Fields

feel like it's a sacrifice at the time? Not usually because we are so anxious to have whatever prized item we are getting.

Nowadays folks are prone to let their credit cards do the buying right now. Saving up for a big purchase seems to be a dying art. As a result, there are thousands, maybe millions of people today in credit card bondage. Slavery of any kind certainly takes the edge off the joy we should feel in enjoying our nice car or sound system.

Credit cards don't let us learn how to save up to buy something. In times before credit cards were so common, people would save up for a significant purchase. They knew the painful practice of not spending that dollar on a current pleasure in order to achieve a greater anticipated future pleasure. Because credit cards have siphoned off this quality from us, many have never learned the principle of financial sacrifice.

This is particularly unfortunate when it comes to people who enter the arts because any and all of the arts require sacrifice. They require the sacrifice of time and effort and often the sacrifice of money as well. People who have never learned to sacrifice in other areas of their lives are entering a battlefield without weapons or no experience with their weapons.

Too many aspiring artists of this generation don't know how to sacrifice for their art. They must learn or be pushed out by those who are willing. They must learn to sacrifice pleasure now in order to further their art. Learn to turn off the TV, forgo drinks with their friends in order to buy tickets to some beneficial or instructive event; don't buy that car and instead use the bus so that you can afford to take the classes that you need to "get somewhere" in your profession.

For years I have shown in my lectures an advertisement created in 1889 by the N. W. Ayer Advertising Agency. It shows a fellow on a bicycle with his arms folded and his feet off the pedals; he's coasting. Behind him we see a whole pack of other cyclists pedaling hard and gaining on him. The headline is a single word: Coasting. It is instantly obvious to the viewer that this fellow is soon going to be surpassed by his competitors.

While it has been said—and I believe it to be true—that ultimately, we only compete with ourselves, even so, we also compete with our fellow-practitioners within our art. A gallery can only show so many paintings, an orchestra can only use so many bassoon players, a stage production only has a certain number of parts and a publisher is only going to produce so many books in a season. To say you don't compete against others is a fable. You do. And you will, as long as you are engaged in your art.

So if you are unwilling to sacrifice to become the best at what you do, there are plenty of others pedaling for all they are worth who will eagerly take your place.

There is an unwritten sign over the gateway to every art that says in bold letters, "The half-hearted need not apply!"

Marketing Yourself

Ralph Waldo Emerson is attributed with having said, "Build a better mousetrap and the world will beat a path to your door." Kevin Costner's film *Field of Dreams* is responsible for adding the following phrase to our modern lexicon and mind set, "If you build it, they will come."

Unfortunately, neither of these sayings is true. And they never have been true. The underlying sentiment is that genuine worth will be naturally acclaimed and sought after. I wish it were so, but tain't so. Real worth is not only rarely sought after, but it is also seldom quickly recognized by the masses. It was acknowledgment of this sad truth that prompted Howard Aitken to say, "Don't worry about people stealing an idea. If it's original, you will have to ram it down their throats." That's true as it relates to the majority of people.

Even the people that are open to and maybe even actively seeking the talent that you have to offer will never give you that opportunity if they don't know you exist or where to find you. And so we come back to the issue of getting yourself known, putting yourself out there. In other words; marketing yourself.

I know, it sounds so vain and crass, but you have to do it. You *don't* have to be tasteless as you do it, but you must promote

yourself. Don't become a shameful self-promoter, but a shameless self-promoter. The world *will not* beat a path to your door on its own, at least not at the beginning.

You may have heard it said that a certain celebrity took ten or fifteen years becoming "an overnight success." The idea is that usually there is a long period of self-promotion and peddling your art before things start to click for you.

So let's revise Emerson's quote to say, "Build a better mousetrap, package it well, market it aggressively and then maybe a few will try it out and someone on TV will see it and talk about it. Then the world might beat a pathway to your door. Not before."

Attitude Equals Altitude

I heard it said once, "I'm not a fatalist; but even if I were, what could I do about it?" It's so funny because there's a spark of truth in it. It can be very hard keeping the dream alive when reality keeps smacking you down.

Herm Albright said, "A positive attitude may not solve all your problems, but it will annoy enough people to make it worth the effort." Of course, faking a positive attitude is not what we're talking about. That's why it is important to have a plan and work that plan. It does something to your attitude that you can't fake.

Too many adopt a "poor-suffering-artist attitude. It may give a certain poetic comfort, but it's terribly self-indulgent and a general turn-off to most other people. Don't go there. Sacrificing for your art can have some real dividends, but overtly and obviously "suffering for your art" is just histrionics.

The poor-me attitude is to willingly taking on the role of a victim. Remember our quotes about luck? A negative attitude will not only bring you down but it will keep you from "getting the breaks." A positive attitude will generate positive vibes and, when you are in the right place at the right time, the breaks will come.

Your friends can help you in this regard, too. They can not only can challenge you, but they can buoy you up during those times that naturally come when you're plagued with self-doubt

and feeling hopeless. If your friends don't do that for you, find some new friends.

Aim for the Top

Don't shrink from the heights just because you are afraid of the possible fall. The old locker room poster was right: "Whether you think you can or you think you can't, you're right."

Here's another aspect of aiming for the top that is more practical. If you really have something wonderful and unique to offer, you're more likely to get recognition from those who really excel in your profession. Sir Arthur Conan Doyle said, "Mediocrity knows nothing higher than itself, but talent instantly recognizes genius." The thought behind this statement is that if you really have something new to offer your art form, the most gifted in your profession are the most likely to recognize it. Therefore, seek out the association of the greatest in your field.

It is unusual for people to achieve higher than their goals. David Joseph Schwartz, author of *The Magic of Thinking BIG*, said, "Think little goals and expect little achievements. Think big goals and win big success." Another thought from someone who ought to know, Donald J. Trump: "As long as you're going to be thinking anyway, think big."

It doesn't make sense to aim for the top and associate with the bottom. I'm not promoting snobbery, just the practical practice of gravitating to the level that you aspire to.

Find ways to associate with or at least be seen by the best in your field. Don't worry if you're not fully matured in your art. Even if you're not quite ready for harvest, you'll get the best cultivation that there is.

Networking

One of the biggest buzzwords of today's popular business culture is networking. But just because it's a hot topic and loads of people are talking about it in a shallow way without doing it or even having the foggiest idea what it really means, doesn't mean that networking is without worth.

Success in the Arts: What It Takes to Make It in Creative Fields

The concept is simple. Learning how to do it, however, takes practice and effort. Networking basically means tapping into the combined knowledge, associations and contacts of everyone you know. One important part of the networking concept that a lot of folks miss is that people will only share their knowledge, associations and contacts with you *if they genuinely like you.*

And people don't generally like someone who's just "looking out for Number One." If you're just schmoozing with someone out of sheer self-interest, only the most dense will not pick up on it. That's generally a turn-off for most people. The only kind of person who will respond at all to that approach are other self-interested exploiters—folks just like you. So watch out for that.

"Two are better than one; because they have a good reward for their labour. For if they fall, the one will lift up his fellow: but woe to him that is alone when he falleth; for he hath not another to help him up." (Ecclesiastes 4:9-10)

This is one of the underlying principles in the famous book *Seven Habits of Highly Effective People* by Dr. Stephen R. Covey. The principle is that you must have a giving attitude about life. You must genuinely want to help people in any way you can. Then their helping you is as natural as a pendulum swinging one way after the other.

Beware! You have to guard against helping people just so that they will help you, because most people will see right through that and will be put off. But if you help from a desire to see others better off, the world has a way of taking care of you. Here's a saying from Ralph Waldo Emerson that we don't need to edit: "It is one of the beautiful compensations of life that no man can sincerely try to help another without helping himself."

Saint Basil said, "A good deed is never lost. He who sows courtesy, reaps friendship; he who plants kindness, gathers love; pleasure bestowed on a grateful mind was never sterile, but generally gratitude begets reward."

And you know what? If you master these things, the opportunities, the luck, the "breaks" will find you more than you'll have to go looking for them.

14. Don't Pop Your Own Bubble

How many holes does it take to pop a bubble? Or a balloon? Just one, right?

So why would we walk around with a pocket full of pins, rusty twisted metal and broken glass?

We'd be wise to get rid of such things, wouldn't we?

In our case, misconceptions or faulty thinking can take the place of those sharp objects and our egos and dreams may just pop. Let's look at a few.

Ease Off Before You Pop

"I like nonsense, it wakes up the brain cells. Fantasy is a necessary ingredient in living; it's a way of looking at life through the wrong end of a telescope, which is what I do, and that enables you to laugh at life's realities." Who said that? Dr. Seuss. It's hard to think of the creator of *Cat in the Hat* or *Green Eggs and Ham* ever getting uptight about anything, but getting on edge is part of the human condition. His counsel is good for us all.

We might liken a creative person to a hunting bow. In order to shoot an arrow with power, the bow needs to be under a considerable tension from the bow's string. But when a bow is not being used it needs to be unstrung. Leaving a bow strung all the time will weaken the best bow and render it next to useless.

So it is with the creative mind. We need to unwind sometimes. We need balance in our lives. Physical, emotional, social and family balance.

Success in the Arts: What It Takes to Make It in Creative Fields

This was known clear back in 400BC when Herodotus, the Greek historian, said, "If a man insisted always on being serious, and never allowed himself a bit of fun and relaxation, he would go mad or become unstable without knowing it."

And if you won't believe Herodotus, listen to Bugs Bunny, "Don't take life too seriously. You'll never get out alive."

Other ways of easing off are journal writing, meditation and prayer. Each causes a quiet reflective spirit to occupy us and can be very beneficial to the regular practitioner. Take your pick or do them all.

Influence, Homage and Plagiarism

When you learn from others, you call it influence. When you copy from others, you call it homage. When somebody else does the same thing to your work, you call it plagiarism. Funny how our perspective is flexible.

But even so, there truly is such a thing as plagiarism. Copying the work of another and passing it off as your own creation is plagiarism. You must avoid plagiarism.

On the other hand, no one learns much all by oneself, unless that person is content to learn very little (you've heard that said before here a few times, haven't you?). We can take classes. We read books (you're doing it now). We seek out mentors. We observe the work of others, especially our favorite practitioners of our particular art form.

So, learning from others can't be inherently bad. It's the most natural kind of learning there is. As infants we all learned to talk and walk by watching our parents and siblings, didn't we?

What we do have to pay attention to is how far to take it. The world doesn't need another singer like Britney Spears, it has one already. It doesn't need another actor like Adam Sandler; one is enough. Or another illustrator like Brad Holland (though there are some who try), he's prolific enough to supply his own market.

Smarts: Don't Pop Your Own Bubble

Finding Your Own Voice

Beginning artists will probably find themselves described as "in the footsteps of" [some established artist]. For instance, Harry Connick, Jr., early in his career was likened to Frank Sinatra, and with good reason. But Harry's gone on to forge his own brand of singing, now. Terry Brooks, author of the Shannara fantasy novels, was likened to Tolkien at the beginning of his career, but has earned a loyal following of his own.

It is the fate of many new artists to be likened to a previous artist. Part of this is the human need to classify, name and label things to better understand them. But part of it may be that beginning artists are often genuinely "influenced" by a previous artist, so that those comparisons are quite justified.

Illustrator Marshall Arisman readily admits an influence from the painter Francis Bacon, whose major work was done a half century ago. Somehow, influences from dead people seem more legitimate than from the living. Why is that? I don't know, but it seems that way to me, too.

In the end, we can't live our life, let alone our artistic career, without being influenced by what we've seen and experienced. It is so pervasive that even the truly great creative minds joke about it. Albert Einstein, one of the most original thinkers of the last century, said, "The secret to creativity is knowing how to hide your sources."

But somewhere along the way, you have to find your own voice. I don't mean that this voice will be devoid of influences. I think that's impossible. But at some point you need to stop asking yourself "How would my hero do this?" and start asking yourself "What is it that this really needs, regardless of what my hero would do?" That will be the beginning of finding your own voice.

In the end, we can't adopt someone else's style in full honesty. Besides, our own style will eventually emerge if we allow it to. And more than likely, we'll bring something original to it that comes from us.

Success in the Arts: What It Takes to Make It in Creative Fields

Never Stop Learning

There is a natural fatigue in being a student and having someone else yanking our chains for assignments, homework, tests and doing things according to *their* criteria. It's only natural that, once out of a school environment, we would want a vacation from that, to rest. The only problem is that virtues are never easy to maintain and vices are hard to avoid. Laziness is a vice and it can be ruinous to your career.

Those who truly become their own masters are the only ones who make it.

Set yourself some realistic goals, plan out the logistics of meeting those goals and work at them. It is very important to write them down somewhere that you will see them, too. Maybe in your bedroom, or next to your mirror. Perhaps you should use a calendar and put some deadlines for yourself on it. Find *some* way to make your goal concrete and urgent. Revise your plan as needed, but don't just "wing it." Keep working your art. Keep growing. Be a steady taskmaster to yourself.

In order to ever amount to anything in any of the arts you must keep growing and experimenting.

I love the way that Tom Hanks shifted his acting career from being a funny guy to being a serious actor—not that comedy isn't serious business. Picasso went through different phases of exploration: his blue phase and then his pink phase and his cubist phase and so on.

One of the greatest illustrators of our time, MacRae Magleby, invented a new style of working with almost every project. Seymour Chwast and Milton Glaser, eminent designers and illustrators both, pushed themselves to generate new styles of working continuously, and yet they each have a visible style in spite of deliberately trying to always work in different styles and techniques. They each did separate books consisting of three hundred portraits of Johann Sebastian Bach in honor of the three hundredth anniversary of his birth, every image theoretically in a different style. (See *Bach Variations* and *Happy Birthday, Bach.*) But the

Smarts: Don't Pop Your Own Bubble

personal voices or styles of both Chwast and Glaser are quite visible; they cannot be silenced. They'd probably be a bit peeved to hear that, but it's true.

You don't need to change your style as long as you are still growing as an artist. But if your art is not new and exciting for you, why would you expect it to be for your audience?

In one sense an artist is almost always dissatisfied with his or her art. Taken to the extreme, this could make us unhappy, maybe even bitter. But it is a good thing to keep challenging oneself and pushing ourselves to seek new heights.

Take Care of Important Things

I would venture to say that as we move along in our careers we will need to make choices about what work we undertake in our art. When we are younger in our careers, we might be happy for *any* work in the field, but as we progress, we will—sooner or later—have to decide what work we will do because we can't do it all. My simple counsel here is to follow your heart.

Any business is not just about selling product (or yourself). Eventually you will realize that it is about relationships. Relationships are what matter in life: relationships with clients, mentors, colleagues, spouse and maybe even children. Those are the important things. Take care of them and the rest will fall where it should be, though that may not be what you intended when you started out.

Speaking of not ending up where you started out, Ben Stein is a great example. He is best known to most of us as an actor and comedian, but started as a lawyer, then an economist. He has also been a law professor and a former White House speech writer. Trust him when he says, "The indispensable first step to getting the things you want out of life is this: decide what you want."

We all have a personal life separate from our artistic life. That's important because we need to be whole people. Whether it is a partner or spouse, we need to care about that person and show it. An artist's career can become all-consuming. But those who let

Success in the Arts: What It Takes to Make It in Creative Fields

it consume too much and lose their family life in the process find that their creative victories are hollow and the praise of the world is a thin substitute for happiness. Invest time in your most important relationships. In the end, they will matter more.

15. Prima Donna or Professional?

Prima Donna is a term for the principal woman soloist in an opera production, literally the "first lady." The term is also used to describe a self-important person who may be capable artistically, but is also insufferably demanding and difficult to please. The term is used mostly as an insult now. It implies rude pride and self-centered opportunism. It means a talented brat.

As mentioned in the chapter on creativity, the culture of artistic entitlement is centuries old, but that doesn't mean it's right. People who think that creative folk are permitted to act poorly ought to also agree that the rich or the powerful have a right to treat the rest of humankind any way they want. Such an attitude sanctions sociopathic behavior and buys into the mentality that promotes a master/slave world.

Why worry about this issue now, you ask, when I am so far from success in the arts? The answer is found in an African proverb: "If you refuse to be made straight when you are green, you will not be made straight when you are dry." So, looking ahead, decide that you will not become a prima donna if-and-when you do become successful.

While it can be easily observed that artistic achievers are sometimes afflicted with these negative human traits, we ought not believe the lie that their creative achievement came *because* of those personality traits, but *in spite of* them. The sentiment expressed by Socrates applies here: "If a man is proud of his wealth, he should not be praised until it is known how he employs it."

Success in the Arts: What It Takes to Make It in Creative Fields

How we act when we are rich is an accurate display of our true character. And we can be rich in many different ways.

A professional, by contrast, is a person who is also quite adept, but works in good faith for the benefit of his or her client. Such a person puts the customer above self. A professional has both pride and humility. There is appropriate pride in putting the job first and of being capable of consistent excellence. The humility is recognition that the performer is not the center of attraction, the performance is. This principle was understood in 500BC when Confucius said, "The man of virtue makes the difficulty to be overcome his first business, and success only a subsequent consideration."

Many have confused the undisciplined Bohemian attitude, that of not conforming to conventions or society, with creativity. But this is another myth that needs to be debunked. Real creativity is more often the product of discipline. And discipline is inherently the result of considerable conformity and practice, not the lack of them. André Gide said, "Art blooms under constraint and perishes under freedom."

You will notice that, ultimately, inspiration (from the muses or otherwise) seems to happen much more to the person who has patiently practiced his or her craft than to the posturing "artiste" given to putting on airs. Real knowledge and craft will invariably out-perform whim in the long run.

Some might think that intuition is a fragile thing that may be destroyed if studied too closely. This is a shallow argument. Intuition is mostly having a feeling that one can't quite articulate. All that means is that the individual doesn't fully understand the principles in question. Once you understand the principles, intuition becomes less operative and confident knowledge takes over.

The Balancing Act

The overstuffed egos seen among certain artistic people, with overweening pride, might considered inevitable for the very successful. Not so. It only happens if they begin to believe the good press written about themselves. They didn't believe the unkind press written about them when they started out; they should

Smarts: Prima Donna or Professional?

maintain that good habit. Ray Bradbury wisely said, "You have to know how to accept rejection and reject acceptance." Don't believe everything you read, even the good stuff.

W. Somerset Maugham understood that achievement does not have to be the doorway into vanity. He said, "The common idea that success spoils people by making them vain, egotistic and self-complacent is erroneous; on the contrary it makes them, for the most part, humble, tolerant and kind."

Self-confidence is a necessary ingredient, not only for the art itself, but for sticking it out during the tough times in such difficult professions as the arts are. But there's a difference between self-confidence and pompous pride. Guard against the latter. The pride that caused Caesars and Pharaohs to buy into their own myths of godhood may seem pitiably comical to us, but it happens all the time in the highest echelons of every human endeavor, not just the arts. Caesars and pharaohs have all gone the same ways as the servant and slave. People who believe in their own godhood, either literally or artistically, are fools. The moody artsy-fartsy prima-donnas act the way they do because of deep-seated insecurity. To themselves they always seem like pretenders to the throne instead of the rightful monarchs. Somewhere deep inside they feel that they are undeserving, but can't find the personal humility to deal with it. Instead, they cover it up with outrageously self-centered behavior. If they would just face their limitations with humility and accept them, they could avoid this trap.

So the war is on inside of you. You can't be neutral. There are the two camps, two ways of being an artist for you to choose from. Pick which side of the battle you will fight for.

Prima-Donna	vs.	Professional
Abandon	vs.	Constraints
Bohemian	vs.	Disciplined
Inspiration and Muses	vs.	Patience and Practice
Whim	vs.	Knowledge
Intuition	vs.	Principles
Artsy-fartsy	vs.	Craftsman

Success in the Arts: What It Takes to Make It in Creative Fields

Walk the Fine Line

And so we must walk the fine line, the straight and narrow path (again). Pushing ourselves to higher accomplishment while recognizing that we never quite achieve perfection. Socrates said, "I know nothing except the fact of my ignorance." A wise man will perceive his own ignorance the more he learns. That will give us proper humility as long as we don't get too impressed with our own success.

This can also be a secret of greater enjoyment. The higher our achievement rises, the harder this will be to maintain. As the old English proverb says, "A full cup must be carried steadily."

In the end, nobody but a self-seeking or co-dependent sycophant wants a person with a self-important attitude to succeed. And who is so big that he or she can't fall from the heights? "If you scatter thorns, don't go barefoot." (Italian proverb)

One of the great defenses against this kind of personality flaw is generosity. Benjamin Franklin said, "Hide not your talents, they for use were made. What's a sun-dial in the shade?" Share your art.

Be humble, don't just act it. It is an essential ingredient in being able to still grow and improve as an artist. Madam Guizot said, "Modesty is a shining light; it prepares the mind to receive knowledge, and the heart for truth." Humility is a true virtue.

As referred to earlier, humility while we are young in our art is more natural. Of course the measure of genuine humility will be later, after we have accomplished something and when we may have reason to be otherwise. As Rose Dorothy Freeman said, "Character is not made in a crisis, it is only exhibited." The real test will come to us with regular and sustained success. Then we will face the test of who we really are. We had better decide now who we want to be.

Section 4:
Heart

Success in the Arts: What It Takes to Make It in Creative Fields

… **Heart:** Paying Your Dues

16. Paying Your Dues

Einstein, Mozart and da Vinci

Do you know any farmer who has ever harvested *before* planting?

Didn't think so.

How like that non-existent farmer we are as wannabe artists. We see the end product and want to do that. It looks so easy. We are sure we can do it. So why do we have to learn all those pesky fundamentals? What if dunderheaded formal education "spoils" us? After all, there have been geniuses that have not gone the standard educational route and not only succeeded, but turned their respective disciplines on their ears, right?

Take Albert Einstein. Didn't he fail mathematics in high school? Nope. It's a myth. Albert not only did well in math, but taught himself Euclidean plane geometry by using a booklet from school. He also taught himself calculus. The myth about his having failed math or algebra in high school is a misinterpretation of grading system numbers from his school records. This Einstein myth is perpetuated because it supports our desire to believe that "gifted" individuals don't have to learn the rules, much less follow them.

What about Mozart? Didn't he write his first concerto at four, a symphony at seven and an opera at twelve? Yes, but that didn't mean he did it without learning the basics of music. He was born into a family of musicians; his father tutored him relentlessly from the age of three and trained him in organ, harpsichord and violin. And he still wasn't "successful" during his lifetime, by most

93

professional, financial or personal standards. But he didn't do his great music just from his personal genius without education; he just didn't get musical education in a school.

What about Leonardo da Vinci? He was the original Renaissance man, a multi-faceted genius: a painter, inventor, engineer and scientist. Many of those pursuits were self-taught, to be sure. But to become a painter he was apprenticed to Verrocchio, a prominent master painter of Florence. You had better believe that he was not exempted from doing all the drudgery and work that apprentices normally did.

Too bad! Three perfectly good myths gone up in a puff of facts!

One of the sad truths of life that any aspiring artist must face is that EVERY creative field requires learning. Masters of the arts often make them look easy, but they aren't. Everyone has to learn the basics thoroughly. Quite often that fundamental learning is not fun or exciting. But it is a necessary foundation on which any artistic career must be built.

You see, any art is a discipline. That word implies being a disciple or student.

And no matter how talented you are, you can't skip this step.

Stretching Yourself

When I was in high school there was a succession of clothing fads that came and went. The *in* people wore the certain article of clothing that was in for a time. If you didn't wear the cool thing, you weren't cool.

Coming from a family of modest means, I didn't usually acquire any of the cool things until after they weren't cool any more. For a time, black cardigan sweaters with gold buttons were all the rage. I got one just when people weren't wearing them anymore.

But one time there was a fad that came that I didn't have to wait for. It was tight fuzzy sweaters. I got one for my birthday, a perfect tight fuzzy sweater, just the kind that was the *in* thing.

Heart: Paying Your Dues

The first time I had ever had any really cool clothes while they were still cool. I wore it every day until it needed washing and then immediately after it came out of the laundry again. My sister and mother both liked the sweater too and asked if they could each borrow it. I didn't give in to their requests until I had worn my sweater for the first month or so. Then I let my sister use it and after, my mom.

When I got it back all washed, I eagerly put it on to wear to school. But to my extreme horror there were stretched LADY BUMPS in the front of my sweater. I tried pushing them back in, but it was no good. The sweater had been stretched and would not go back to its original shape.

My one time to run with the cool crowd was over. I ended up giving the sweater to my mom and sister, because I couldn't wear it anymore.

That is a process I recommend: getting stretched. Generally, it is not something we enjoy happening to us, like I didn't enjoy what happened to my sweater. It is often too painful to inflict upon yourself in normal circumstances, so you have to devise situations to get yourself into where you must really stretch. And stretch so much that you won't go back to the old shape you were before. A good education in your discipline will do that. Then, after your education, don't be timid. Dive in and take every opportunity to grow beyond your present limits. Theodore Roosevelt once said, "Whenever you are asked if you can do a job, tell em, 'Certainly, I can!' Then get busy and find out how to do it." He knew how to stretch himself.

I followed that path in my own career and it has paid off very well. I think anyone who has achieved much has done the same.

Get Going

When I began teaching graphic design in the college, our male to female ratio was about sixty-forty. Over the years that ratio evened up to fifty-fifty and in recent years it has gone to forty-sixty. We initially thought that our profession was becoming more

Success in the Arts: What It Takes to Make It in Creative Fields

attractive for females, but we found that male enrolments in all programs throughout the college were down. Why?

The answer came back: too many guys are at home addicted to video games. Many young men play fifteen to thirty hours a week. Why aren't they enrolling in college? They can't be bothered with education; they have *important* missions to fulfill clicking their controllers, joysticks and mice. Apparently, it is a phenomenon all over North America.

The arts are wonderfully fulfilling as careers. That's why thousands of hopefuls enter those professions all the time. One thing any aspiring artist must be very clear on: those willing to settle for mediocrity just won't cut it. If you want a spot in these fields, you will have to compete for your place. If you are only willing to give a half-hearted effort, there are a dozen people who will sweep you right out of the line-up because they are fully committed to making it. Dedicated video game hobbyists (that's the nicest way to refer to such addicts) aren't willing to dedicate the passion to their art because they already have something else they've chosen to be passionate about.

The same goes for other forms of addiction: alcohol, drugs, gambling and pornography. There are some who appear to not be affected—for a while. But it *always* catches up to them in the end. Some of these, such as alcoholism, also have more obvious destructive effects, but all addictions have in common the ease with which they can progress from diversion to obsession. If you want to amount to anything in your profession, artisic or otherwise, keep yourself free from addictions. You can't afford the strength; your art will take all your strength. You can't afford the time, either.

Liz Smith laid it on the line when she said, "Begin somewhere; you cannot build a reputation on what you intend to do." Get busy. Remember Aesop's fable of *The Tortoise and the Hare*? The hare was so sure of his speed that he took a nap and the slow and steady tortoise won the race. Don't feed on a diet of intentions. "The smallest good deed is better than the grandest intention." (Author Unknown)

Heart: Paying Your Dues

Don't wait to be "discovered." Don't wait for fate to do things for you. Be proactive, a doer, not a dreamer. The great author, G. K. Chesterton, said, "I do not believe in a fate that falls on men however they act; but I do believe in a fate that falls on them *unless* they act."

Don't "just play it by ear." Make some goals. Feel free to revise them as needed, but living life without goals is like sailing with no one at the wheel. Why bother? Jim Rohn, recognized as the greatest motivational speaker of all time as well as an author and business executive, gave this advice, "The major reason for setting a goal is for what it makes of you to accomplish it. What it makes of you will always be the far greater value than what you get."

Many people resist setting themselves goals. They think that by not doing so they are preserving their options. What they are really doing is forfeiting their options. Goals don't have to be tattooed onto you. They don't have to be permanent. Not only can you revise your goals, but you should at least review them on a regular basis.

The essential thing is to DO SOMETHING with a bit of direction. Like Woody Allen says, "Eighty percent of success is showing up."

Tough Times

Even talented folks will have tough times. It's part of the learning process of growing up in your field. Mentors can guide, teachers can instruct, peers can support. But the only one that can learn the art is YOU!

There will be sad times, discouraging times and times of self-doubt. Thomas Edison, the great inventor, said, "I admit I had days of such discouragement that I ached to give it all up. But something kept me going. I guess it was faith, the kind you have when you're young, and don't know any better."

That's what the theatrical profession calls heart. "You gotta have heart. Lots and lots and lots of heart!" (lyrics by Eddie Fisher)

Pam Brown reminds us, "The baby rises to its feet, takes a step, is overcome with triumph and joy—and falls flat on its face.

Success in the Arts: What It Takes to Make It in Creative Fields

It is a pattern for all that is to come! But learn from the bewildered baby. Lurch to your feet again. You'll make the sofa in the end."

Face Your Bullies

Time for another story. Got your milk and cookies ready?

When I was six years old, there was this one bully in the neighborhood that kept beating me up. My dad had counseled me that I needed to just stand up to this kid and he'd leave me alone. Of course, parents don't know anything, so I ignored them and stuck to my strategy of running like a rabbit.

One day my parents looked out of the living room and saw me dashing toward home for all I was worth, with the bully in hot pursuit. Do you know what they did?

They locked the front door! I ran up the steps and—gasp!—I couldn't get in! Trapped like a rat. Cornered. Nowhere to go.

What happened next?

To tell the truth, I don't know. Must have been traumatic stress amnesia. The kind soldiers have in battle. I don't actually remember it. But my parents were crying and watching from behind the living room shear curtains. They saw and told me how I beat the crap out of that bully.

And Dad was right. The bully never bothered me again.

So, how does that relate to your career in the arts?

The principle is this: you need to get yourself into situations where you will either produce or face disaster. Necessity is the mother of invention--true. But *survival* is the mother of squeezing the best out of you. Some of us just can't reach our personal resources, hidden at the bottom of our souls, without a pressing, urgent, vital and critical need.

Herbert A. Otto, the psychologist and leader of the human potential movement, said, "Change and growth take place when a person has risked himself and dares to become involved with experimenting with his own life."

So, don't go looking for bullies, but definitely push the limits. The bullies will find you on their own. Face them, and that will help you grow, too.

17. You Gotta Have Heart

Facing Criticism

Once there was an unfortunate old mule that fell into an abandoned dry well on his master's farm. The farmer saw the mule fall in the well and came over for a look. He couldn't figure out how to get the mule out of the well and then decided that old mule wasn't worth the trouble. He also made up his mind that he'd better fill in the old well before something more valuable fell in.

So he got his hired hand and they began to shovel in dirt. At the bottom of the well the dirt fell on the mule and before long his hooves were covered to the ankles and there was a big pile of dirt accumulated on top of him.

The mule couldn't believe this treatment from the farmer after all his years of faithful service. He was angry and decided to not give in. He shook off the dirt on his back and head and stepped out of the dirt and onto the higher level.

Over and over he did this: shake it off and step up. Shake it off and step up. Before long the well was all filled to the top and the mule stepped out on the ground again. The farmer laughed and decided that any animal that determined was worth keeping after all. Of course, the mule never really trusted the farmer again, but he lived out his life on the farm.

Personal Taste

Artists will always be faced with those who don't appreciate what they do. After all, not everyone likes broccoli or peas. Per-

sonal taste is a strange thing. To each individual, those things that taste bad are repulsive. For instance, I have a hard time swallowing cooked carrots or beets. They actually make me retch. I love the colors. They appeal to me as an artist, and I wish I could eat them for their color alone, but the taste gets to me and I really have to repress a gag reflex to get any down. I know, I know! They're good for you. They're not harmful or poisonous. Tell that to my throat.

Other things I can take or leave: chocolate, for instance. My wife, on the other hand, finds chocolate hard to resist.

That's personal taste. Some people like one thing and others hate it. Their reasons aren't rational, but that doesn't make their reactions any less real. So as an artist, you will always have the rejection of those who just don't like your work. Some people like Meg Ryan as an actress and some don't. Nothing you can do about personal taste. The only artists everyone likes are those long-dead ones who have become a part of the "canon" in their field (and truth be known, everybody *doesn't* really like them, we just concede to the norm that these folks are great, yada, yada, yada). If you are ever accepted after your death, you won't know about it. Artists who are OK, with rejection their whole lives in the thin hopes that they'll be appreciated after they're gone are folks that I don't understand at all.

In our little mule analogy, the dirt falling on the mule is personal rejection. The farmer didn't value the mule and some people won't value you or your work. Whatever field you enter, there's going to be some of that. Maybe a lot. Eric A. Burns said, "Humanity can be quite cold to those whose eyes see the world differently." But comfort yourself in this: Brendan Francis Behan said, "Critics are like eunuchs in a harem; they know how it's done, they've seen it done every day, but they're unable to do it themselves." Other people say that those who can, do; those who can't, teach; and those who *really* can't, become critics.

What do you do with personal taste heaped upon you that doesn't like your flavor? Shake it off and step up! Rise above it.

Heart: You Gotta Have Heart

Valid Criticism

Now let's take the analogy a bit further. What if the farmer and his hired hand had decided that the well was a perfect place to get rid of an inconvenient large stone and they had rolled it to the mouth of the well and dropped it in? Our story would end with a dead mule and wouldn't be nearly so inspiring. However, smaller rocks, the kind that would be part of a shovel full of dirt, could cause the mule to shrink and wince, but he'd probably survive them.

Those smaller rocks correspond to genuinely deserved criticism of our work. Usually it gets shoveled onto us with a lot of the dirt of personal taste. Sometimes it's hard for us to distinguish between the two kinds of stuff hitting us. Only one way to tell: the rocks and the genuine criticism hurt more than the dirt of personal taste. That's how I've learned to tell the difference between criticism that reflects individual preference and the legitimate critical judgments of my work.

What should we do about it? Well, if you or I were down in the well, we might hug the side of the walls. We'd also likely cover our heads with our arms and just try to weather the storm. "The gem cannot be polished without friction, nor man perfected without trials." (Chinese Proverb) We still need to shake it off and step up—after noting those accurate criticisms.

We must recognize that sometimes the criticism of our work is valid. The critic just might have a point. Maybe we should consider what is being said. Sometimes it will be a key to improving your art. But, other times it's just a cold-hearted farmer filling up his well—just the dirt of personal taste not liking your work.

Figuring out which criticism is valid and which should be put behind us is another one of the skills you'll pick up while "paying your dues." It's a bit of an art in and of itself, this learning to deal with criticism. People are naturally likely to react to criticism in one of two ways.

On the one end of the spectrum we have people who don't listen to anybody. We might call them mulish (no pun intended)

103

or pig-headed. They probably think they are being "true to their own vision." Maybe they are. Or maybe they're just too self-centered to listen to anybody else. People that just won't learn from others won't get very far. If you're *only* going to learn what you discover on your own, by yourself, you're not going to learn much in this life (is there an echo in here?). There's too much to learn to afford to not learn from others.

On the other end of the continuum we have folks who are cut to the heart by everything said by everybody. They don't get very far, either. Criticism is inevitable in any career as well as careers in the arts. It hurts, especially if it's accurate. Sometimes it can make us shrink from wanting to do more. If we let it pummel us into inaction, we'll be buried for sure. Ambrose Bierce in *The Devil's Dictionary* said "Painting is the art of protecting flat surfaces from the weather and exposing them to the critic." It makes no sense being in any creative field if you're too thin-skinned to take some disapproval. If all you want is for people to like you, give them money instead of art.

In the middle ground, you listen carefully to all of the praise and disapproval and weigh it carefully and sort it into correct piles. Learn from the well-founded observations of your work, ignore the rest.

Don't be afraid of making mistakes. If you are, you'll never really put yourself out enough to amount to anything. Thomas Edison said, "Results! Why, man, I have gotten a lot of results. I know several thousand things that won't work." It's easy for us to look at someone who succeeded so well, like Edison, and forget all the failures that led him to his successes. For every bulls-eye there will be dozens or hundreds of missed shots. That's the way things are. Keep shooting. Wayne Gretsky the great hockey star, said, "You miss one hundred percent of the shots you don't take."

Consider Your Sources

Another way to help you filter the feedback you will get is to consider the giver of the feedback. Edmond de Goncourt, writer,

Heart: You Gotta Have Heart

publisher and critic, once said, "A painting in a museum hears more ridiculous opinions than anything else in the world." Ask yourself if the critic has demonstrated that he understands what you were trying to accomplish before criticizing your end product.

A colleague I worked with for fifteen years never played music in his office, whereas I almost always had music going in mine: opera, country, movie soundtracks, international music, classical, folk, oldies, blues—I like a wide variety. Every year at we sat next to each other at an event and stood together to sing the national anthem. Even though he wasn't musically inclined, I had noticed that he could find and follow the melody well enough.

One day I mentioned to him that I had recently done some back-up singing on a CD and that I sing bass in our church choir.

He was surprised. "How can that be? You can't carry a tune!"

"What makes you think that?" I asked.

He said earnestly, "For years I've heard you singing the national anthem and you don't hit a single note right."

I laughed. "That's because I always sing the *bass part* to the national anthem." He didn't know enough about music to recognize the bass part and thought I was singing wrong notes. It's no crime that he didn't know music. It just wasn't one of his interests. But my knowing where he was coming from was important for me to appraise his observations of my singing.

Sometimes you get criticism from people who just don't know enough about your art form to make any kind of informed opinion. In the case of my colleague, if he had been talking to me about his area of expertise, I would have been foolish to ignore his insight. He truly excelled in that. But the area of music was clearly outside of his areas of experience and he had no foundation there. So, too, you must evaluate where your criticisms come from.

On the other hand, my wife has had no graphic design or illustration training apart from what she has picked up by being married to me. Even so, I find she has an uncanny ability to see

105

real flaws and real strengths in my work. I have found her untutored eye to be remarkably accurate. Find sounding boards you can trust.

You Still Have to Be Yourself

It's absolutely impossible to please everybody. Don't even try. Bill Cosby said, "I don't know the key to success, but the key to failure is trying to please everybody." In the end, after all the input the world has to offer—and it will be a lot—it doesn't make any sense to form yourself totally by the criticisms, even the ones you consider valid. Be aware of them. Learn from them. Be honest in acknowledging your weaknesses.

But at some point you have to be yourself. Otherwise it's just a masquerade. You need to let the real YOU out sooner or later.

18. Getting and Giving

Life as Art

Here's another concept to add to the ones that we've already discussed: life itself is an art. The living of life requires talent, heart and smarts. Some people learn to do it well and some learn it rather poorly.

In the end, I don't think you can judge those who have learned well how to live life by whether they have also been a success in their artistic fields. Life is a different and separate art from music, painting, acting, etc.

I know there are some people who say that film is their whole life. Or writing, or dance. Perhaps they are being metaphorical. Perhaps they mean that at this particular period in their lives, their art is the most important and all-consuming passion in their lives. That's OK – for a season. But if they really mean and aspire to nothing higher than their art, they will find any victories in their art rather hollow indeed.

Life *is* an art, but life is *more* than just art. Life is relationships and love and commitment to something bigger than or outside of oneself. Ben Franklin observed, "A man all wrapped up in himself makes a very small bundle." We could say the same about persons all wrapped up in nothing but their art.

How many successful artists have we seen in any of its forms that are highly praised as artists, and that have nothing but drugs or alcohol or serial sex to turn to for personal fulfillment?

Success in the Arts: What It Takes to Make It in Creative Fields

How pathetic to have climbed to the top of your ladder only to find out that it was leaning against the wrong wall. To lighten their upward climb they have jettisoned everything that might have made their triumph worthwhile: friends, spouses, children, maybe even their personal morality. When they arrive at the top, they are alone and internally destitute.

That same culture of entitlement, spoken of earlier, that tries to tell us that artists are allowed to live outside the normal bounds of manners and decency, also tries to tell us that a "true artist *must* suffer for his art." This whole idea of the mystique of the artist is loaded with false notions about not only the inevitability of suffering for one's art, but also tries to have us believe it is desirable or even necessary. That's a lie.

As mentioned before, many beginning artists get sucked into this "poor-suffering-artist" syndrome in which they buy into a vision of themselves as the star in a tragic opera or movie.

While I have been very clear that we need to make sacrifices for our art, there are and must be limits to what we can or should sacrifice. Ancient wisdom asks us "What is a man profited if he shall gain the whole world, and lose his own soul?" (Matthew 16: 26)

So how do we guard against that and how can we avoid this common trap?

One important thing we can do is to learn to give instead of just take, not just to our art world, but to other people: our friends and family.

The key to having a positive attitude is to be doing something positive for others. Victims are at the mercy of the fates, at the mercy of others. They see themselves as powerless receivers of whatever life and others with power decide to do to them. They are the pawns in someone else's game. That's rather pathetic.

Conversely, pro-active people see themselves as receivers and givers, able to be affected by others, but able to make changes for good in others as well. All of us need to find ways to give to others. It may involve our art or not. We all have much that we can give.

Teaching to Give Back and to Learn

While it is natural to take teachers in our lives for granted, I must admit that I owe so much to each one of my teachers, even those who affected me less. Many, especially the ones in my art career, have been immensely important to me.

One of the ways to keep one's perspective and to "give back" to the world is to teach. Even if we are not at the top of our ladder, we may know enough to be a help to someone several rungs below us. Teaching can be a significant contribution to many others. But what may surprise you is that if approached correctly, you will learn *more* than you have taught.

My teaching has gotten me more in touch with the underlying principles of my art. I think that if correctly approached, it will do the same for you. The act of teaching, by having to express things to other people, will help you solidify principles in your mind. Maybe it's the sheer volume of work that you must shepherd and judge. You will know one student's work is ineffective in a certain area, but not know why. And then you will see another student's work that did it right and the light will go on inside your head. These eureka moments are some of the finest rewards of teaching.

In my teaching of visual subjects, I always show both good and bad examples. If I only show good samples, the students will just accept them and may still not understand the principle being taught, but bad ones seem to really drive the point home.

Nothing could have been more helpful to me than teaching to discover those basic truths of graphic design. The reward is that every time I was evaluating student work I was discovering or reenforcing what the underlying principles were.

Teaching will teach you most.

Service will serve you most.

Giving will give you most.

And loving will fill you with love the most.

All the nineteen years while I have been teaching full time, I have also continued to freelance as a designer and an illustrator. It was during this period that my work became used around the

Success in the Arts: What It Takes to Make It in Creative Fields

whole world. But I can honestly say I have learned more about both design and illustration from teaching than I have from all the rest of my professional work combined. Teaching has taught me a great deal. I am grateful for the privilege.

No One Wants to be a Wannabe

I was listening to a podcast a while ago in which a woman was telling about having given a lecture on book publicity (which she is an expert on) to a group of self publishers. Afterwards a lawyer came up to her and asked her how he might get publicity for his book. The woman was taken aback because the thrust of her whole lecture had been how publishers need to do *all* the things that publicity depends on: prepublication reviews, ongoing reviews in all the media, radio interviews, book distribution and so on. She tried to recap these principles for this man but he brushed it aside and again asked how he could get publicity for his book. It was very obvious to this experienced woman that this man thought that because he was established in his own profession of law, that somehow he could jump the queue in the profession of publishing.

That's what a wannabe is: someone who thinks that they can arrive at the top of the mountain without climbing it. They are looking for the helicopter ride to the summit without the work of the hike. That may work for rich guys on real mountains, but it doesn't work in the real world in *any* career. Wannabes are amateur dabblers who won't submit to the discipline of the art form, but still think they can make it in the professional arena.

Wannabes are different from hobbyists who are practicing an art for their own enjoyment. Wannabes are guilty of the pride that makes them feel that they are special and are somehow exempt from the law of paying their dues. Being called a wannabe is no compliment.

Because of that, we ought not to use the term too quickly.

In every field there are those who want to join it and/or excel in it. Those persons should be called "aspiring artists," which is a respectful term. Some people who are maybe a bit established

Heart: Getting and Giving

in their professions might view such persons as "wannabes." That has a less respectful connotation and is a judgment that is both unkind and unjust. A legitimate student of any art ought not to be looked down upon by those farther along on the same path. That's just the schoolyard bully sickness with different trappings.

Instead, real hopefuls in any of the arts should be mentored and helped. Teaching, as mentioned above, will be rewarding for the disciple and the tutor.

All teaching need not take place in a classroom. As I mentioned about my great teacher who was so influential to me, most of his truly pivotal influence on me took place outside of the classroom. I don't think it has to be that way. I just mention it to reinforce the notion that beneficial teaching can take place anywhere and anytime, regularly scheduled or sporadic, a one-time shot or over a period of years.

The important thing is to be of a mindset to give of yourself and your knowledge at all times and wherever you can. Don't forget the "little people," not because you are a magnanimous benefactor of your great wisdom. To someone else, you are "little people." Keep your perspective and humility. Give in order to give back for all that you have received, either from your own mentors along the way or from a kind providence that gave you natural advantages (talent).

It is important to consider your talents and abilities not as things that you possess outright, but as things over which you have a stewardship. Somehow we are all accountable for what we have and how we use it. It doesn't matter if it is money, power, position, talent or insight.

Don't Give Up

Remember, your career is a marathon, not the 100 meter dash. It doesn't matter as much if you are first as much as that you finish the course. In a real marathon, who gets the biggest cheers? It's not the person who finishes first, it's the one who overcame all odds, when all other competitors have given up and is the last runner to finish.

111

Success in the Arts: What It Takes to Make It in Creative Fields

The upward climb can seem to last forever. In reality, it *is* never-ending—unless you are planning on hitting some pre-determined plateau and squatting there. What becomes tiresome to the aspiring artist is not achieving some significant milestones. It is important, therefore, to take note of the less significant milestones. Don't fall into the trap of feeling that the race is not going well just because you're not at the finish line yet. The race has something to celebrate all along its track.

If nothing else, notice those things that are starting to become easier. Ralph Waldo Emerson noted, "That which we persist in doing becomes easier, not that the task itself has become easier, but that our ability to perform it has improved." That can also be a reason for celebration.

And while we're talking about persistence, remember what Calvin Coolidge said:

"Nothing in the world can take the place of persistence. Talent will not; nothing is more common than unsuccessful men with talent. Genius will not; unrewarded genius is almost a proverb. Education will not; the world is full of educated derelicts. Persistence and determination are omnipotent. The slogan 'press on' has solved and always will solve the problems of the human race."

The hardest part of any race is just before the finish line. Imagine running a race where you couldn't see the finish line. It would be hard to keep up our drive, wouldn't it? But that is exactly how our careers and our lives are run. We just don't know what day will be our last. We could die any day. We also don't know ahead of time when the big breaks are going to open up for us. Thomas Edison, who certainly knew the meaning of perseverance, said, "Many of life's failures are people who did not realize how close they were to success when they gave up."

So keep going, keep trying. But you'll find it hard to do that if the only goal that's meaningful to you is your ultimate goal. You have to take pleasure in all of your smaller achievements along the way. Then one day a door may open for you and success will be there for you.

19. What if I Don't Make It?

Dr. Edwin Land, creator of Polaroid photography, said, "An essential aspect of creativity is not being afraid to fail." If you believe him — I certainly do — then that means we will fail many times on our pathway to success. It's part of the process.

Artists are always refining their craft. In any chosen art we "fail forward to success." Failure is inevitable. Not ultimate failure. Not permanent failure. But we learn by trying and failing until we succeed. It is true in our art. It is also true in our life.

Even though we might fail many times, we don't lose until we give up. An old Japanese proverb says, "Fall down seven times; get up eight."

Or if one avenue is closed to us, we can go down another road. As the ancient Romans used to say, "If the wind will not serve, take to the oars."

We may find that our original goal is just not going to work for us. Does that mean we have failed?

Suppose I Don't Meet My Goals?

In life we must make choices. Sometimes we choose a course of action, but are less than honest about *why* we chose it. Let us make honest choices.

If I gave something my best try and honestly failed, at least I tried. If I hadn't at least tried, I'd always wonder if I *could* have done it. John Greenleaf Whittier gave us this memorable bit of wisdom: "For of all sad words of tongue or pen, the saddest are

Success in the Arts: What It Takes to Make It in Creative Fields

these, 'It might have been!'" Trying and failing is still better than not trying.

There is a story about a farmer who was teaching his son to plow a field. "The key to nice, straight furrows, Son, is to look at some object at the far end of your field. That will keep you going straight." The farmer left the son to plow while he attended to some other chore. When he returned he saw his son's plowed field, but there were gaps and double-plowed sections everywhere. The father asked the son why he hadn't followed his counsel. The son replied, "I *did* look at something at the end of the field—but the cow kept moving!"

Some people just can't make up their minds what they want, flitting from one goal to another. We tend to think of them as a bit unstable. On the other hand, to make a decision and stick to it, even if it was a wrong decision would be rigid, inflexible and not too smart, either. Somewhere in between there's a good balance to be struck. Sometimes in life our goals change as we grow up or mature in different ways. That's just part of living.

Often people's life goals are set when they are young. Maturity can give us a different perspective on our goals. Quentin L. Cook tells a story about his young son who had appendicitis and was operated on by his Uncle Joe, a surgeon. After that experience the boy decided to be a doctor. After a few months he changed his mind and decided he would be a fireman when he grew up. His father asked him why he changed his mind and the boy replied, "I still like the idea of being a doctor, but I have noticed that Uncle Joe works on Saturday mornings, and I wouldn't want to miss Saturday morning cartoons."

We laugh at the limited vision of a nine-year-old boy. Doesn't he know he'll outgrow his obsession with Saturday morning cartoons? And yet, most of us set many of our goals when we were much younger than we are now and, therefore, relatively less mature. We may have doggedly stuck to those goals for years without ever re-evaluating why we wanted to achieve them. No one admires a quitter. At the same time, we might have set ourselves

Heart: What if I Don't Make It?

some lifetime goals that we may find that we have outgrown if we'd just take the time to seriously reflect on them.

Notwithstanding my childhood goals to be an artist, as I mentioned earlier, by the time I graduated from high school, I had decided on a career not in art after all, but on marine biology. I had become very impressed with the work of Jacques Cousteau and wanted to spend my life exploring the mysteries of the sea.

After a year and a half at the University of Maryland with marine biology as my declared major, I took a two-year break in my schooling to serve a mission for my church in Argentina. When that was completed, I had done some soul-searching and realized that my goal of swimming with the sea critters would be at conflict with another of my life goals, to have a happy marriage and raise a large family. I would likely be unable to come home in the evenings to my family if I was off to the South Seas, or wherever my research took me. I had also re-evaluated my motivations for my marine biology goal and found that they weren't as deep-rooted as my desires to make art. So upon finishing my missionary service, I changed universities and changed my major to art.

Have I ever regretted not going into marine biology? No. In life we have to make choices. If our choices have been made while being honest with ourselves, why should we regret them? Choices made for immature reasons, or reasons that no longer make sense to us, on the other hand, can be full of conflicts. They are unlikely to bring us happiness in the long run.

Albert Schweitzer said, "A man can do only what he can do. But if he does that each day he can sleep at night and do it again the next day."

Seymour Chwast, the great designer and illustrator, once said, "You have to know how far to go. If the idea doesn't gel after a certain amount of struggle, you have to give up. I read once about lateral and vertical ideas. If you dig a hole, and it's in the wrong place, digging deeper isn't going to help. With the lateral idea, you skip over and dig someplace else." In this instance, I think he was referring to the creative process of finding solutions to artistic problems, but these words also easily apply to our life choices.

Success in the Arts: What It Takes to Make It in Creative Fields

Hardy D. Jackson said, "Above all, be true to yourself, and if you cannot put your heart in it, take yourself out of it."

If you spend your life running east, you will never see a sunset. If that's your honest choice, fine. But count the cost before starting. Then, too, sunrises are pretty neat, as well.

Your personal happiness is more important than your art. I was fortunate in that I never had to choose between my art and my personal happiness. But, if you have to choose between the two, I think anyone would be a fool to choose their art.

Remember, you are not your job title, or your professional awards, or your income, etc. The world's praise is a temporary thing. You are a whole person and you must look after yourself.

The Journey and the Destination

Life is a journey. If we are only satisfied when we reach our planned destination, ignoring the journey itself, we will have forfeited much of life, thrown it away. In contrast, if we have enjoyed the journey and along the way something causes us to change our objective or prevents our reaching our target, we at least have enjoyed the voyage.

Any art is enriching. Millions of people do art of various kinds just for the sheer pleasure of it. Even if you do not end up remaining a professional in your chosen art forever, what you will have learned will enrich your life forever. Whatever the outcome of your career in art, you are among the fortunate few—who--even if only for a while—aspired to be a professional in your art. That is a rare privilege that millions of retail workers, office workers, laborers of all kinds, can only dream of.

Maybe your career path took you to a fork in the road. Remember the poem by Robert Frost?

It begins, "Two roads diverged in a yellow wood,
And sorry I could not travel both . . ."

At the end of the poem he writes,

"Two roads diverged in a wood, and I—
I took the one less traveled by,
And that has made all the difference."

Heart: What if I Don't Make It?

Many people have used that poem to justify or maybe even glorify the path that they have chosen. That's not bad in itself. A person could use that to say, in effect, "The majority haven't chosen the path of higher discipline that the arts require, but I have. And that has made all the difference."

Conversely, one might quote that same poem and be really saying, "Many people in the arts are willing to sell their morality, their artistic integrity or their very souls to get certain breaks in our industry, but I haven't. I chose the path less traveled by and *that* has made all the difference."

Ambassador Randy Tobias, former CEO of AT&T and other companies, said, "Life is too short to work some place where you are not having fun."

The world's measure of success does not have to be yours. Helen Hayes, the great actress of stage and screen, said this: "My mother drew a distinction between achievement and success. She said that 'achievement is the knowledge that you have studied and worked hard and done the best that is in you. Success is being praised by others, and that's nice, too, but not as important or satisfying. Always aim for achievement and forget about success.'"

But if I leave my goal of being an artist, even to save my marriage or some other worthy consideration, won't some people consider me a loser? Maybe.

Dr. Seuss, the great children's book author and illustrator, gave this counsel: "Be who you are and say what you feel, because those who mind don't matter, and those who matter don't mind." And Eleanor Roosevelt gave this famous advise, "Do what you feel in your heart to be right, for you'll be criticized anyway. You'll be damned if you do and damned if you don't."

It is more important to be a successful person than to be a successful artist. As always, the choices are yours to make. You have to live with them.

I genuinely wish you a life of fulfillment and happiness.

117

Success in the Arts: What It Takes to Make It in Creative Fields

20. Final Words

As with all arts, there are principles that don't change. They are true and enduring. I have seen them work in my own life, the lives of my children as well as that of countless colleagues and students in my field and other artistic fields. I have endeavored in this book to point out some of those principles as they relate to success in the arts.

As I mentioned earlier, the most important thing that you could get from this book would not be some specific knowledge about your art, but an adjustment to your attitudes and outlook as it relates to your chosen art form.

Even so, everyone who reads this book will filter its message through his or her own experiences and prejudices. People will have their own take on the content. That's just the way we all learn.

May true success be your goal and reward.

Success in the Arts: What It Takes to Make It in Creative Fields

About the Author

For 19 years Michael Shumate has been teaching at St. Lawrence College in Kingston, Ontario, where he is a Professor of Graphic Design and Illustration. He has taught Color Theory, Beginning, Intermediate and Advanced Illustration including Computer Illustration, Branding Design and Art History.

In addition to teaching, for more than 35 years Michael has been a graphic designer and commercial illustrator, a conceptualizer and writer, an organizer and motivator. For the seven years before becoming a teacher, he was Senior Designer/Illustrator for a mid-sized design studio and advertising agency.

Michael's design experience extends to all areas of graphic design including advertising, corporate identity, institutional design, annual reports, display and interpretive center design as well as print and web design. As a stock illustrator with *TheImageBank.com, GettyOne.com* and *Theispot.com*, Michael's illustration work has been used all over the work for such clients as *British Airways Magazine*, Kelley Services, Macmillan McGraw-Hill publishers and *Business Week*. He is fluent in many illustration styles and in virtually every medium: oil, acrylic, pastel, watercolor as well as digital media of Illustrator and Photoshop. For a wide sampling of Michael's design and illustration work, see the stock illustration sites mentioned above or www.VisualEntity.com.

Michael has been a popular speaker for youth and adult audiences on a range of topics including those embodied in *Success In The Arts. What It Takes to Make It in Creative Fields.*

Success in the Arts: What It Takes to Make It in Creative Fields

Index

A

Abandon 90
abstract 19
addiction 96
Howard Aitken 76
Geoffrey F. Albert 11
Herm Albright 76
alcohol 96
Woody Allen 97
aptitude 35
Louis Armstrong 56
Life as Art 107
Art 107
poor suffering artist 77
Artistic knowledge 34
arts 56
Artsy Fartsy 90
art is enriching 118
Attitude 76
attitude, importance of 34
Auditory-Musical 40

B

Bachelor of Arts degree 29
Bachelor of Fine Art degree 29
Back Burner 53
Sir Francis Bacon 71
Brendan Francis Behan 48, 102
Be Yourself 106
Ambrose Bierce 104
Josh Billings 59
Clarence Birdseye 61
Body-Kinesthetic 40
Bohemian 90
Ray Bradbury 89
brains 41
Brainstorming 52
Getting the Breaks 71
Brigham Young University 15
Pam Brown 98
Face Your Bullies 98
Eric A. Burns 102

C

careers 28
caterpillars 60
Chekhov's Gun Rule 64
G. K. Chesterton 97

Chicken Imperial 53
Winston Churchill 42
Seymour Chwast 84, 118
cleverness 55
Coasting 75
Langston Coleman 73
color 66
Confucius 88
Constraints 90
Conventions 63
Conventions, Rules and Principles 63
Quentin L. Cook 116
Bill Cosby 106
conflicting council 7
contradicting myself 10
Dr. Stephen R. Covey 79
Stephen Covey 34
Craft 37
Craftsman 90
crea 65
creative arts 40
Creativity 49
Creativity 49
education 65
Creativity 51
Facing Criticism 101
Valid Criticism 103
Criticism is inevitable 104
Cycle 58

D

Leonardo da Vinci 94
Charles Dickens 67
Disciplined 90
Walt Disney 42
diving coach 10
Don't Pop Your Own Bubble 81
dormant aptitude 36
Sir Arthur Conan Doyle 77
draw 14
drawing 17, 57
drugs 96
Paying Your Dues 93
Dr. Wayne Dyer 11
Dyslexia 41

E

Ease Off Before You Pop 81

123

Success in the Arts: What It Takes to Make It in Creative Fields

Thomas Edison 104, 113
Thomas A. Edison 71
Thomas Edison 97
education 34
education 65
ego 8
Albert Einstein 83
Albert Einstein 42, 54, 61, 93
Eat an Elephant 27
Elvis 56
embouchure 37
Ralph Waldo Emerson 75, 79, 112
end-run 55
expectations 34
exploiters 78

F
fables 34
Face Your Bullies 98
Facing Criticism 101
Film 9
Finding Your Own Voice 83
folklore 34
football 55
Henry Ford 42
Benjamin Franklin 90
Rose Dorothy Freeman 91
Robert Frost 119
fulfillment, from work 35

G
"good enough" 72
"good enough" 73
Kenneth Galbraith 11
Gallup 40
gambling 96
Howard Gardner 40
James A. Garfield 71
genius, must still learn 36
Getting and Giving 107
Getting and Giving 107
Milton Glaser 84
Edmond de Goncourt 105
You Gotta Have Heart 101
Grand Poobah 7
Graphic Design 8
graphic design 17
Madam Guizot 90

H
Helen Hayes 119

hearing, to play music 36
Heart 23
Talent, Mind and Heart 32
heart 11, 55
passion for the work 22
put in the time 21
talents, hearts and minds 11
You Gotta Have Heart 101
Earnest Hemmingway 42
Influence, Homage and Plagiarism 82
how-hard-can-it-be? 72

I
illiterate people and creativity 55
Illustration 8, 18
illustration 27, 30
conceptual illustration 31
immaturity 28
inclination 35
Influence, Homage and Plagiarism 82
Inspiration & Muses 90
Intelligence 39
Interpersonal Communication 40
Intrapersonal Communication 40
Intuition 90
IQ tests 40

J
Hardy D. Jackson 118
Japanese garden 45
Thomas Jefferson 71
Steve Jobs 42

K
Knowledge 90
knowledge, artistic 35

L
Dr. Edwin Land 115
Never Stop Learning 84
Life as Art 107
life is more than just art 107
Limitations shrink through acquired skills 23
"little people" 111
John Locke 33
Logical-Mathematic 40
looking out for #1 78
Sophia Loren 48
Luck 71

M
magic 21, 27, 34
What if I Don't Make It? 115
Thomas Mann 72
Marine Biology 117
Mark Twain 42, 46
Karl Marx 68
W. Somerset Maugham 89
media, fleeting expertise 37
Mentor 59
Michelangelo 42
Michelangelon and Raphael 50
Mickey Mouse 13
The Mikado 8
Milton Glaser 84
talents, hearts and minds 11
Catch a Monkey 25
Mozart 93
Mozart 68
mule in the well 101
Muses 50
music 9
Myth #1 on Creativity 49
Myth #2 on Creativity 49
Myth #3 on Creativity 50
Myth #4 on Creativity 51

N
Nurture or Nature 42

O
opportunities 79
Herbert Otto 99

P
"Poor Suffering Artist" syndrome 108
Painting 19
painting 14
passion 32
Patience and Practice 90
Paying Your Dues 93
Peers 60
Personal Taste 102
Pablo Picasso 42
Influence, Homage and Plagiarism 82
Grand Poobah 10
Grand Poobah 8
poor suffering artist 77
Popular art or Purist? 67
pornography 96
portfolio 91

practice 37
Preparation 72
Prima-Donna 90
Prima Donna or Professional 87
Principles 63, 65, 90
Professional 90
Prima Donna or Professional 87

R
Raphael and Michelangelo 50
Rebellion not "edgy" 65
Nelson Rockerfeller 42
Jim Rohn 97
Royalty free photography/illustration 31
Rules 63, 64
Bertrand Russell 7

S
"suffer for your art" 108
Sacrifice 74
schmoozing 58
David Joseph Schwartz 78
Arnold Schwarzenegger 56
Albert Schweitzer 117
Seed Model 46
Self-knowledge 39
Dr. Seuss 81, 120
Skill 35
skills, transformed from aptitude 36
Talent, Mind and Heart 32
laterally what you can't do directly 22
smart 21
smarts 23, 59
talents, hearts and minds 11
cleverness 55
end-run 55
Smarts 55
snobbery 35
Ralph W. Sockman 65
Soil Model 45
Consider Your Sources 105
Britney Spears 82
Steven Spielberg 42
Mickey Spillane 69
St. Basil 79
Ben Stein 85
stick figure 21
Stock photography and illustration 31
Strengths 40
Stretching Yourself 94
style 28

125

Success in the Arts: What It Takes to Make It in Creative Fields

succeed in the arts 9
becoming an overnight success 76
successes 59
talent 22
succeed in the arts 9
sweaters 95

T
acquired mastery 23
inborn abilities 23
Intelligence 39
talent 11, 22, 55
talents, everybody has some 3
talents, hearts and minds 11
talentum 39
talent, aptitude 35
Definition of Talent 39
Talent, Mind and Heart 32
Talent 45
abilities 28
Talent 22
Talent 21
Seed Model 46
Soil Model 45
public speaking 23
Parable of the Talents 47
Talents 48
Personal Taste 102
Teaching to Give Back 109
Teaching to Learn 109
Thinking Outside the Box 53
Randy Tobias 119
tolerance 69
Tricks 57
Donald J. Trump 78
two-dimensional images 27

U
Back Burner 53
University of Maryland 117

V
Valid Criticism 103
Henry Van Dyke 72
Vincent Van Gogh 42
Verbal-Linguistic 40
video games 96
Visual-Spatial 40
VisualEntity.com 24
Finding Your Own Voice 83

W
Wannabe 110
Andy Warhol 56
George Washington 14
What if I Don't Make It? 115
Whim 90
John Greenleaf Whittier 116
John Williams 68
folk wisdom 7

Y
You Gotta Have Heart 101

Success in the Arts: What It Takes to Make It in Creative Fields

Do you know someone who wants a career in any of the arts?

Quick Order Form

Check your favorite bookstore or online bookseller or call 24/7 to order by phone: 800-247-6553

Order online at www.ElfstonePress.com

(volume discounts available)

or copy this form to order by fax: 419-281-6883

❑ US residents:

I want _____ copies of *Success In the Arts*
 at $10.95US
 plus $4.00 shipping per book. (shipped from US)
 (Ohio residents add 74¢ sales tax)
 Total

❑ Canadian residents and international:

 I want _____ copies of *Success In the Arts*
 at $10.95US
 plus $8.00 shipping per book.
 Total

Charge my ❑ VISA ❑ MasterCard ❑ AMERICAN EXPRESS

Card Number _____

Expiration Date ____/____ Security Code _____ Signature _____

Name as on card _____

Ship to _____

Address _____

City _____ State/Province _____

Zip/Postal Code _____ Email _____

Due to a n error in the design phase, the wrong Table of contents and Index were printed with this book. Here is the corrected Table of Contents and Index. We appologize for this error.

Corrected Table of Contents

SECTION 1: PERSONAL EXPERIENCE		9
1. Who Is the Grand Poobah?		11
2. Fame at an Early Age		17
3. Trial By Ordeal		21
4. The Issue of Talent		25
5. To Catch A Monkey		29
• Eat an Elephant		31
6. Challenging Decisions		33
SECTION 2: TALENT		37
7. Everybody has some talents		39
• The Magic of Talent		39
• Inclination, Aptitude and Skill		41
• Talent and Tangent Skills		42
• Craft		42
8. Discover Your Talents		45
• Definition of talent		45
• Intelligence		45
• Personal Strengths		46
• Dyslexia		47
• Nurture or Nature?		48
9. Models of Talent		49
• The Soil Model		49
• The Seed Model		50
• Why Worry About It?		52
10. What is Creativity?		53
• What Creativity Isn't		53
• What Creativity Is		55
• Brainstorming		56
• Thinking Outside the Box		57
• Using Your Back Burner		57
SECTION 3: SMARTS		59
11. Using Your Smarts		61
• Learning Tricks		63
• The Cycle		64
• Seek a Mentor		65
• Cultivate Challenging Peers		66
12. Conventions, Rules and Principles		67
• Conventions		67
• Rules		68
• Principles		69
• Popular Art or Purist?		71

13. Getting the Breaks		75
• Luck or Leverage?		75
• Get Out There		75
• Underestimating Your Profession		76
• Work Your Plan		77
• The Art of Sacrifice		77
• Marketing Yourself		79
• Attitude Equals Altitude		80
• Aim for the Top		81
• Networking		81
14. Don't Pop Your Own Bubble		83
• Ease Off Before You Pop		83
• Influence, Homage and Plagiarism		84
• Finding Your Own Voice		84
• Never Stop Learning		85
• Take Care of Important Things		87
15. Prima Donna or Professional		89
• The Balancing Act		90
• Walk the Fine Line		92
SECTION 4: HEART		93
16. Paying Your Dues		95
• Einstein, Mozart and da Vinci		95
• Stretching Yourself		96
• Get Going		97
• Tough times		99
• Face your bullies		100
17. You Gotta Have Heart		101
• Facing Criticism		101
• Personal Taste		101
• Valid Criticism		103
• Consider Your sources		104
• You Still Have to Be Yourself		106
18. Getting and Giving		107
• Life As Art		107
• Teaching to Give Back and Learn		109
• No One Wants to be a Wannabe		110
• Don't give up		111
19. What If I Don't Make It?		113
• Suppose I don't Meet My Goals?		113
• The Journey and the Destination		116
20. Final Words		119
About the Author		121
Index		123

Corrected Index

A
Abandon 91
abstract 23
addiction 98
Howard Aitken 79
Geoffrey F. Albert 15
alcohol 98
Woody Allen 99
aptitude 41
Louis Armstrong 62
Life as Art 107
Art 107
poor suffering artist 80
Artistic knowledge 40
arts 62
Artsy Fartsy 91
art is enriching 116
Attitude 80
attitude, importance of 40
Auditory-Musical 46

B
Bachelor of Arts degree 33
Bachelor of Fine Art degree 33
Back Burner 57
Sir Francis Bacon 75
Brendan Francis Behan 51, 102
Be Yourself 106
Ambrose Bierce 104
Josh Billings 65
Body-Kinesthetic 46
Bohemian 91
Ray Bradbury 91
brains 47
Brainstorming 55
Getting the Breaks 75
Brigham Young University 19
Face Your Bullies 100
Eric A. Burns 102

C
careers 32
caterpillars 66
Chekhov's Gun Rule 68
G. K. Chesterton 99
Chicken Imperial 57
Winston Churchill 48
Seymour Chwast 86, 115
cleverness 61
Langston Coleman 77
color 70
Confucius 90
Constraints 91
Conventions, Rules, Principles 67
Quentin L. Cook 114
Bill Cosby 106
conflicting counsel 11
contradicting myself 13
Dr. Stephen R. Covey 82
Stephen Covey 40
Craft 42
Craftsman 91
crea 69
creative arts 46
Creativity 53, 55
creativity and education 69
Facing Criticism 101
Valid Criticism 103
Criticism is inevitable 104
Cycle 64

D
Leonardo da Vinci 96
Charles Dickens 71
Disciplined 91
Walt Disney 48
diving coach 14
Don't Pop Your Own Bubble 83
dormant aptitude 41
Sir Arthur Conan Doyle 81
draw 18
drawing 21, 63
drugs 98
Paying Your Dues 95
Dr. Wayne Dyer 15
Dyslexia 47

E
Ease Off Before You Pop 83
Thomas Edison 75, 99, 104, 112
education 40, 69
ego 12
Albert Einstein 48, 58, 85, 95
Eat an Elephant 31
Elvis 62
embouchure 43
Ralph Waldo Emerson 79, 82, 112
end-run 61
expectations 40
exploiters 82

F
fables 40
Face Your Bullies 100
Facing Criticism 101
Film 13
Finding Your Own Voice 85
folklore 40
football 61
Henry Ford 48
Robert Frost 116
fulfillment, from work 41

G
"good enough" 75, 77
Kenneth Galbraith 15
Gallup 46
gambling 98
Howard Gardner 46
James A. Garfield 75
genius, must still learn 42
Getting and Giving 107
Milton Glaser 86
You Gotta Have Heart 101
Grand Poobah 11
Graphic Design 12, 21
Madam Guizot 92

H
Helen Hayes 117
hearing, to play music 42
Heart 26
Talent, Mind and Heart 36
heart 15, 61
passion for the work 26
put in the time 25
talents, hearts and minds 15
You Gotta Have Heart 101
Earnest Hemmingway 48
Influence, Homage, Plagiarism 84
how-hard-can-it-be? 76

I
illiterate people and creativity 61
illustration 22, 31, 34
immaturity 32
inclination 41
Influence, Homage and Plagiarism 84
Inspiration & Muses 91
Intelligence 45
Intrapersonal Communication 46
Intuition 91
IQ tests 45

J
Japanese garden 49
Thomas Jefferson 75
Steve Jobs 48
K
Knowledge 91
knowledge, artistic 41
L
Dr. Edwin Land 113
Never Stop Learning 86
Life as Art 107
life is more than just art 107
"little people" 111
John Locke 39
Logical-Mathematic 46
looking out for #1 82
Sophia Loren 52
Luck 75
M
magic 25, 31, 40
What if I Don't Make It? 113
Thomas Mann 76
Marine Biology 115
Mark Twain 48, 50
Karl Marx 72
W. Somerset Maugham 91
media, fleeting expertise 42
Mentor 65
Michelangelo 48
Michelangelon and Raphael 54
Mickey Mouse 17
The Mikado 12
Milton Glaser 86
talents, hearts and minds 15
Catch a Monkey 29
Mozart 95
Mozart 72
mule in the well 101
Muses 54
music 12
Myths about Creativity 53, 54
N
Nurture or Nature 48
O
opportunities 82
Herbert Otto 100
P
"Poor Suffering Artist" syndrome 108
Painting 18, 23
passion 36
Patience and Practice 91
Paying Your Dues 95

Peers 66
Personal Taste 101
Pablo Picasso 48
Influence, Homage, Plagiarism 84
Grand Poobah 12, 14
Popular art or Purist? 71
pornography 98
portfolio 35
practice 43
Preparation 75
Prima-Donna 89, 91
Principles 67, 69, 91
Professional 91
R
Raphael and Michelangelo 54
Rebellion not "edgy" 68
Nelson Rockerfeller 48
Jim Rohn 99
Royalty Free photography and illustration 35
Rules 67, 68
Bertrand Russell 11
S
"suffer for your art" 108
Sacrifice 77
schmoozing 64
Arnold Schwarzenegger 62
Seed Model 50
Self-knowledge 45
Dr. Seuss 117
Skill 41
skills, built from aptitude 41
Talent, Mind and Heart 36
laterally what you can't do directly 26
smart 25
smarts 27, 65
talents, hearts and minds 15
cleverness 61
end-run 61
Smarts 61
snobbery 41
Ralph W. Sockman 69
Soil Model 49
Consider Your Sources 104
Britney Spears 84
Steven Spielberg 48
Mickey Spillane 73
Ben Stein 87
stick figure 25
Stock photography, illustration 35

Strengths 46
Stretching Yourself 96
style 32
succeed in the arts 13
becoming an overnight success 80
successes 65
sweaters 96
T
acquired mastery 27
inborn abilities 27
Intelligence 45
talent 15, 25, 26, 49, 52, 61
talents, everybody has some 4
talentum 45
talents and abilities 32
talent and aptitude 41
Definition of Talent 45
Talent, Mind and Heart 15, 36
Talent and Seed Model 50
Talent and Soil Model 49
Talent and public speaking 27
Talents, Parable of 51
Talents and Personal Taste 101
Teaching to Give Back 109
Teaching to Learn 109
Thinking Outside the Box 56
tolerance 73
Tricks 63
Donald J. Trump 81
two-dimensional images 31
U
Back Burner 57
University of Maryland 115
V
Valid Criticism 103
Vincent Van Gogh 48
Verbal-Linguistic 46
video games 98
Visual-Spatial 46
VisualEntity.com 27
Finding Your Own Voice 85
W
Wannabe 110
Andy Warhol 62
George Washington 18
What if I Don't Make It? 113
Whim 91
John Williams 72
folk wisdom 11